ARTIST & ALPHABET

TWENTIETH CENTURY
CALLIGRAPHY AND LETTER ART
IN AMERICA

TWENTIETH CENTURY
CALLIGRAPHY AND
LETTER ART
IN AMERICA

Artist & Alphabet

CURATED BY

JERRY KELLY & ALICE KOETH

WITH AN INTRODUCTION

BY DONALD JACKSON

PUBLISHED BY

DAVID R. GODINE, PUBLISHER · BOSTON

IN ASSOCIATION WITH

THE AMERICAN INSTITUTE OF GRAPHIC ARTS

AND THE SOCIETY OF SCRIBES

Da v i d R. G o d i n e , Publisher, Inc.

Box 450

Jaffrey, New Hampshire 03452

website: www.godine.com

The publication of this catalogue has been made possible in part by the
generosity of our major sponsor
F u r t h e r m o r e , the publication program of The J. M. Kaplan Fund.

We are deeply grateful for the support of our sponsors and donors:

Neenah Paper, *Patron*

E. K. Success, Ltd., *Supporter*

American Greetings, *Donor*

BIC Corporation (Schaefer), *Donor*

The Gladys Krieble Delmas Foundation, *Donor*

Anonymous Member, *Donor*

JoCarole and Ronald S. Lauder, *Donor*

Dr. and Mrs. Jerry Lynn, *Donors*

Emily Brown Shields, *Donor*

and to the many corporate, member and individual donors
whose financial contributions have made
this exhibition possible.

i s b n : 1-56792-118-3 (Hardcover)

i s b n : 1-56792-137-x (Softcover)

This catalogue and exhibition
are dedicated to our friend and colleague

PHILIP GRUSHKIN

1921 – 1998

who was called away in the middle
of the party preparations

FOREWORD

It's wonderful to watch people and things grow: kids, flowers, and even calligraphy societies. In 1974 when a group of scribes signed up to learn the making of gesso and the laying-on of double illuminator's gold leaf from Donald Jackson, there was little thought, then, that one day we would be celebrating a twenty-fifth birthday.

In celebration of twenty-five years

Not unlike kids, the Society of Scribes grew in spurts, sometimes in almost meditative slowness and at other times in a furious burst of creative activity. Through it all we're a quarter-century older, and very much like kids, thought it time to have a party – an exhibition.

With the anniversary of the century coinciding with our anniversary, it was decided that an exhibition and accompanying catalog surveying some of the contributions of this country in the field of calligraphy and the letter arts seemed almost inevitable.

Several ideas were floated about how best to review this subject. We considered including a wider range of letter arts, encompassing more commercial lettering art and type design; covering the international community, and perhaps even including exotic alphabets; in the end scarce space and resources forced the exhibition committee to limit this survey. We circumscribed the selection of work based on the following criteria: 1. the work of American calligraphers, with the exception of four European scribes who greatly influenced letter artists in this country; 2. work only in the Latin alphabet and its variant hands; 3. work produced between 1900 and 1999; and, 4. work produced mainly in calligraphy and lettering, not type design.

Whittling the guest list to a manageable number was a difficult task. It was impossible to invite everyone we wished to be part of this exhibit and because of this, inevitably, some very qualified work is not pres-

ent. The calligraphers were invited to submit a piece of their choice or, in some cases, a piece by our suggestion of the representative style of an individual. Also, due to prior commitments, a few artists were unable to accept our invitation. Surely, each individual involved in the field would have selected or deleted several of the pieces included here, but if no one were to venture to exhibit and publish such a selection there would be no party at all. Seventy-four contemporary calligraphers are part of the celebration and twenty-eight historic figures, from whom we have learned so much and whom we remember with affection.

The curators wish to thank the exhibition committee: Robert Boyajian, Diane Brandt, Karen Charatan, Anne Doyle, Ward Dunham, Elinor Holland, Joanne Insigna, Maureen Parisi, Ina Saltz, Paul Shaw, Margaret Williamson, Jeanyee Wong, and Lili Wronker for their help; and to thank in particular for all their patient work and enthusiasm, Sharon Arditty, Will Farrington, David Gatti, Margaret Neiman Harber, Ted Kadin, Loraine Klara, Carole Maurer, Deborah Nadel, Anna Pinto, Gwen Weaver, and Eleanor Winters. And we are especially grateful to Mary Anne Wolfe, President of the Society of Scribes, the glue that held all of this together.

<div align="right">

Alice Koeth & Jerry Kelly
New York City

</div>

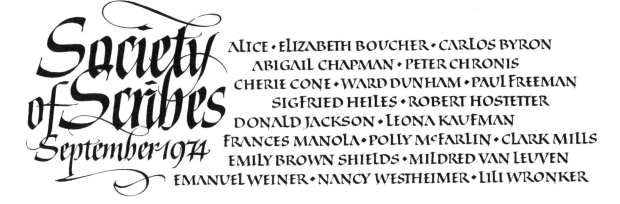

Society of Scribes
September 1974

ALICE • ELIZABETH BOUCHER • CARLOS BYRON
ABIGAIL CHAPMAN • PETER CHRONIS
CHERIE CONE • WARD DUNHAM • PAUL FREEMAN
SIGFRIED HEILES • ROBERT HOSTETTER
DONALD JACKSON • LEONA KAUFMAN
FRANCES MANOLA • POLLY McFARLIN • CLARK MILLS
EMILY BROWN SHIELDS • MILDRED VAN LEUVEN
EMANUEL WEINER • NANCY WESTHEIMER • LILI WRONKER

As I write these words with a ball-point pen on a legal pad, I glance over to some delicately surfaced vellum samples I have just brought back with me from Jerusalem. They lie slightly curled on my drawing board beside my pens and inks, tempting me to play with them instead. I want to dip into the glossy ink with a goose quill and discover what happens, what shapes will grow from the flexing and twisting strokes as my hand, only half-consciously, moves over the peachskin nap of the parchment. Voluptuous or slim, slow-flowing or staccato, stomped impetuously or stroked on, gentle as breath, the shapes grow, calling out to be touched, surprising me with what appears.

As an artist I suppose it is understandable that I should start by talking about the sensory and visual aspects of the writing process. But our civilisation has also invested enormous intellectual, cultural, and emotional significance in these "toys" of ours, probably more than most of us will ever know. When we first attached little bits of the language we speak to specific letter-shapes, we committed them to a relatively conservative place in our collective psyche. Legibility, after all, depends on familiarity, and familiarity depends on continuity. Some letters trace their origins to marks scratched or drawn thousands of years ago onto Mesopotamian clay tablets or papyrus rolls. So when we "meddle" with letters we risk creating a sense of unease in the reader by chal-

(above) The original members of the Society of Scribes, calligraphy by Alice Koeth

The origins of our letters

lenging the familiar; who knows, we may also be stirring more complex subliminal reactions by tampering with the symbolic roots of the alphabet!

In many circumstances then, there are limitations to our play. But deep roots do not mean that new forms cannot evolve over time, that our inky fingers and venerable craft condemn us to the repetition of old-fashioned or archaic symbols. Those anciently rooted marks, those even older and deeper passions for play and delight in invention and symbolism, tap into endless sources of inspiration which revitalise and re-inform the work of each new generation of lettering artists.

The works in this Society of Scribes Twenty-fifth Anniversary Exhibition cover a wide range of calligraphy and lettering designs for many different functions and purposes. Some are printed by machine, while others are crafted by hand. Corporate logos and carefully honed advertising display fonts—whether polished and retouched by brush or tweaked pixel by pixel on a computer—keep close company with gold-leafed scrolls and spontaneously made, deeply personal pirouettes of the pen, blots and all. The makers of all these designs are linked by a shared love of "playing" with letters and driven by a longing to be surprised by what will appear. The wide variety of works in this exhibition, whatever their intended function, proves it.

Historical figures and events

We all stand on the shoulders of those who have gone before us. Looking back to the work of the craftsmen and women of previous generations whose work inspires us now, it is evident that a common feature of their working lives was membership in some kind of community, a guild, perhaps, which provided a structure and context for sharing information, skills, and experiences, as well as support.

Formation of the Society of Scribes

This same spirit of sharing prompted a small number of mostly professional calligraphers and lettering artists to convene at the home of Lili Wronker in September, 1974, where they formed the Society of Scribes. They had first met as a group in the inaugural class at the Calligraphy Workshop founded by Louis Strick earlier that year. The sense of community engendered there had encouraged them to get together again.

Their numbers quickly grew and now, twenty-five years later, established artists as well as beginners with little more to offer than their enthusiasm are still welcomed, encouraged, and inspired.

The Society of Scribes was formed against the background of a growing popular interest in calligraphy and lettering arts in America. This was itself part of a more general rediscovery and exploration of craftwork as a spiritually rewarding and recreational pastime. Of course, there were already professional lettering artists and specialist calligraphers throughout the United States, some of whom enjoyed an international reputation for their work and as teachers and authors. New York, in particular, was home to a number of experienced and highly trained individuals who worked either for themselves or in publishing and advertising. Some taught classes that ranged from hobby to degree levels. In addition, almost every other major American city supported at least one engrossing studio, some of which relied on freelance calligraphers. Though specialist groups of lettering artists, calligraphers, and interested "book people" had occasionally been formed in several of these centers, none had really flourished for long.

The teaching of calligraphy

What seemed to make a difference in the late 1960s and early '70s was the growing number of beginners who wanted to learn about calligraphy. The majority sought self-realisation—calligraphy for its own sake—not a diploma or a career. Many of the older generation of professional calligraphers had, one way or another, taken up calligraphy for the very same reason. So they responded to the enthusiasm of the newcomers and made common cause. The Society of Scribes, along with other groups which began to mushroom around the United States at the same time, was quite literally founded out of a mutual love for the making of calligraphy and lettering. This fact still lies at the heart of the work of the society to this day.

From my own experience of teaching in the United States during the 1970s and early '80s, it was clear that most of the new students were women. Attending a calligraphy class, for some at least, was a first tentative step toward exploring their creative potential.

Some may have enrolled in a class at the local Y offering the ubiquitous Italic or Black Letter because it seemed to be a relatively unthreatening start. Many found a pleasurable and rewarding pastime (the word therapeutic was often used), others, surprised by the extent of the challenge moved on to try less demanding crafts. Some of those who persisted, enthralled, became the next generation of professional calligraphers and teachers. Exposed to the potent pains and pleasures of the pen and brush, all had their eyes opened to the exciting visual possibilities of the alphabet which permeated their daily lives.

American influence overseas

The growing numbers of student calligraphers enabled the publisher Louis Strick to justify investment in international editions of "How To" books and anthologies of calligraphers' work. His lead was soon followed by others, including several guilds who began publishing highly professional journals and technical information for their members. Before long, the energy and excitement of this "New Wave" of American calligraphers had reached Europe, the very place from which its inspiration and much of its tradition had first come. This American influence has extended even as far as China and Japan where Society of Scribes members have given formal classes in Western calligraphy. In 1981 the Minneapolis Guild initiated a series of international conferences, now held in different parts of the United States each year. They provide a truly international forum for all levels of interest in the lettering arts.

First exhibition

Announcement of the first exhibition by Alice Koeth

By December of 1975, the budding New York group felt ready to hold its first public exhibition, organized at the Bergen (NJ) Community Museum of Art and Science. At the time—they did ask me—I felt the society was showing a little too much verve and enthusiasm; it seemed far too early for members to be exposing their work to critical assessment in an unjuried public exhibit where the work of novices mixed with that of experienced professionals. I was quite wrong and Paul Freeman, the society's founding chairman, was right. Showing was just another way of sharing, and sharing, he knew, was the group's reason for being. So many viewers were inspired by that show and by successive ones that membership in the society soon approached 2,000.

The number of student calligraphers appears to have leveled off since the 1980s; nonetheless, it seems to me that general standards, for both professional and amateur, have risen over the last twenty-five years. Journals such as *Letter Arts Review* and its familial predecessors provide a fascinating visual record of calligraphic evolution during most of this period. There is evidence all around us of the influence of calligraphy and lettering on our everyday graphic environment. If the Yellow Pages are any indication, there are now more commercially active professional calligraphers and letter designers in the US than ever before.

What of the future? After the invention of printing in the largely secular West, calligraphers were frequently categorised in the public mind as diploma filling scrollmongers (all those cartoons about monks!), or as servants of commercial art and signage. I have certainly been most of those things and now (whilst I am not yet a monk) really am working on a Bible for an American monastery. Thus achieving the ultimate cliché role.

Ironically, who could have foretold that the dreaded computer, once supposed to make us redundant, would, in fact, contribute so generously to a wider public appreciation for our personal and expressive work and to a greater demand for our creative ideas? Lay audiences now clearly understand me when I talk to them about the visual consequences of choosing different scripts—I just call them fonts. Terms like "linespacing" and "grids" have passed into our current vocabulary, while the knowledge that apparently rigid families of alphabetic symbols can now be manipulated and printed out in different textures, colors, and layouts has become common currency in millions of homes and offices. I believe that the computer has altered the ordinary person's conscious and unconscious relationship to the artistic possibilities of text. For those who create personal works of calligraphic art, a new climate of receptivity may well be developing unbidden. Novel and short-life fonts and display faces for use on computers seem to be in constant demand, and the Internet presents an endless and unjuried gallery space, free to all. Calligraphers, who have trained eyes, draw

Influence of the computer

Current vocabulary

their ideas from deep roots and delight in looking for visual surprises. Perhaps, they are the best placed of all to match the need; I, for one, believe that they are rising to the challenge.

I am certain that any major influences and developments in the lettering arts, as in almost everything else, will continue to lie in the hands of eccentrics, obsessive odd-balls, dreamers, and loners who seem to spend all their time playing, while more sensible folk are holding down "proper" jobs. I'd like to think that if, once in a while, some of them feel the need to get together with others of their kind in order to feel more normal, then the Society of Scribes will still be here to welcome and encourage them.

Don't be deceived. Everything in this show (not just the more obviously free-fall expressive work), was at one level or another an excuse for us closet dreamers to play. Hands and tools were guided by a selfish desire to create beauty, symmetry, and maybe even mischief. Look hard and you will find that we will have probably revealed far more than we know or had ever intended for you to see.

Donald Jackson
Monmouth, Wales

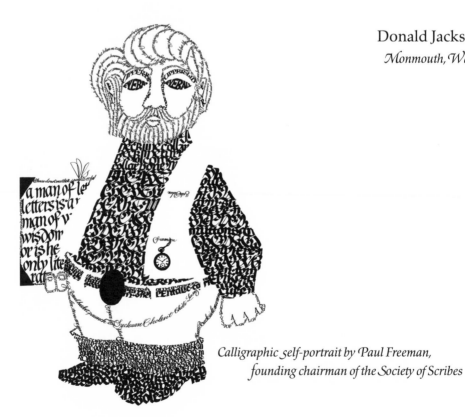

Calligraphic self-portrait by Paul Freeman,
founding chairman of the Society of Scribes

14

ARTIST & ALPHABET

TWENTIETH CENTURY
CALLIGRAPHY AND LETTER ART
IN AMERICA

THIS IS A SPECIMEN SHEET OF Calligraphy;

Disciplined freedom is the Essence of it

{ AS OF ANY OTHER JUST FORM OF GOVERNMENT }

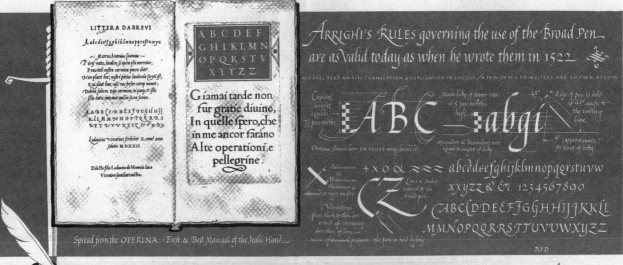

Spread from the OPERINA: First & Best Manual of the Italic Hand.

ARRIGHI'S RULES governing the use of the Broad Pen are as valid today as when he wrote them in 1522

HIS FULL TEXT AWAITS TRANSLATION & PUBLICATION IN ENGLISH / A FEW OF HIS PRINCIPLES ARE SHOWN BELOW

1

ARRIGHI was equally well known as VICENTINO, a surname derived from his native village, VICENZA.

2

Calligraphy's Flowering, Decay, & Restauration
by PAUL STANDARD
(Society of Typographic Arts)
CHICAGO, 1947

3

Ecce Mundus—The Book Beautiful
LONDON, 1902
The fuller Quotation is: "When printing was young the Printer carried into type the tradition of the Calligrapher and of the Calligrapher at his best. As this tradition died out in the distance, the craft of the printer declined. It is the function of the Calligrapher to revive etc…"
+
He added that the Printer "must at the same time be a Calligrapher, or in touch with him…"

VARIOUS CALLIGRAPHICAL AUTHORITIES ARE AGREED that the best model for the instruction of handwriting is the Chancery Cursive, a style which attained its highest development in the early XVI century. Its leading exponent was LUDOVICO DEGLI ARRIGHI[1] of VICENZA. His work was widely imitated throughout Europe but by 1800 had given place to mercantile hands that could be written with greater speed.[2] When these, with later & still speedier methods gave way to the typewriter and the business machine, handwriting as an art, fell to its nadir. Within the past fifteen years, however, there have been signs that Calligraphy is coming back, chiefly by way of Book Publishers who were the first to sense that the freedom & warmth of Humanistic writing can supplement Type, and may even replace it in full pages of text on appropriate [but rare] occasions.

This lends support to R. COBDEN SANDERSON'S contention that[3] It is the function of the Calligrapher to revive and restore the craft of the Printer to its original purity of intention and accomplishment. It is not suggested here that the earliest Types, which were naturally based on calligraphic forms,

Eastern's Atlantic Antique Laid is a crisp, crackling, genuinely watermarked paper with the look & feel of exceptional quality. Uniform in every respect, its tub-sized surfaces take Offset, or Letterpress, or Pen equally well. Free from waves, wrinkles, or curl, and precision cut on all 4 edges, it runs easily on the press without trouble or fuss. An impressive paper worthy of the finest printing, Eastern's Atlantic Antique Laid is ideal for special jobs & for outstanding letterheads, envelopes, brochures, and folders. Specify this distinguished sheet for your best customers. Its cost is much less than its quality would indicate.

should be revived, nor that calligraphic mannerisms should be imitated in modern Types, for that, as pointed out by STANLEY MORISON,[4] is artificial, and inconsistent with the nature of printing which is a branch of engraving. Rather, the plea is for an accordance such as existed between the early Printer and his Calligrapher for whatever benefits may be derived now, as then, from shared knowledge. In this connection it may be mentioned that ARRIGHI, himself, in 1523, worked as a printer in partnership with LAUTIZIO BARTOLOMEO DEI ROTELLI, the greatest engraver of his time. Directness is mandatory in the use of the Broad Pen—the Scribe's task being to make good letters with the fewest possible strokes and to maintain an even texture and temper without retouching. White is a betrayer, a sneak, and an ever present help in time of trouble. A fairly constant rate of speed also helps to hold the necessary regularity of pattern throughout the mass, whether in a single line of text or in a full page. The faster the speed the more flowing and connected the letters become, hence the term Cursive; but whether the letters are made in the Cursive or in the slower style of roman majuscule & minuscule [caps & lower case] the operation, in calligraphic parlance, is still called writing.

The above roman is based on ARRIGHI'S writing, 1520, in the Colophon of the MISSALE ROMANUM

4

THE ART OF Printing
(The Diamond Classics)
NEW YORK, 1945
A small book (4⅞ x 3⅛) of highly concentrated information on the relation of printing and calligraphy, with a comprehensive Bibliography.

N.B. A definition of Calligraphy by STANLEY MORISON: Calligraphy is the art of fine writing communicated by agreed signs. If these signs or symbols are painted or are engraved on wood or on stone; we have that extension of writing known as LETTERING, ie, a large Script generally formed with mechanical aids such as the rule, compass, & square. But it is the essence of handwriting that it be free from such, though not from all government, & of beautiful handwriting that it possess Style… Calligraphy may be defined as free hand in which the freedom is so nicely reconciled with order that the understanding eye is pleased to contemplate it.

YOU MAY DEPEND ON ITS FINE PRINTING QUALITIES

THIS IS A SPECIMEN SHEET OF EASTERN'S ATLANTIC ANTIQUE LAID CREAM, SUBSTANCE 24, MADE BY

Eastern Corporation · Bangor, Maine

Makers of ATLANTIC BOND and other Fine Business Papers

PRINTED IN U.S.A. – COPYRIGHT, EASTERN CORP. 1948

1. RAYMOND F. DABOLL (1892–1982) Newark, AR
Disciplined Freedom, 1948
Offset printed (from original calligraphy)

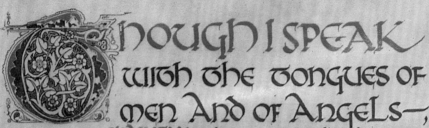

Though I speak with the tongues of men and of angels—, and have not CHARITY, I am become as sounding brass, or a tinkling cymbal. And though I have the gift of prophecy, and understand all mysteries, and all knowledge, and though I have all faith, so that I could remove mountains, and have not CHARITY, I am nothing. And though I bestow all my goods to feed the poor, and though I give my body to be burned, and have not CHARITY, it profiteth me nothing. CHARITY suffereth long, and is kind, CHARITY envieth not, CHARITY vaunteth not itself, is not puffed up. Doth not behave itself unseemly, seeketh not her own, is not easily provoked, thinketh no evil, Rejoiceth not in iniquity, but rejoiceth in the truth, Beareth all things, believeth all things, hopeth all things, endureth all things. CHARITY never faileth, but whether there be prophecies, they shall fail, whether there be tongues, they shall cease, whether there be knowledge, it shall vanish away. For we know in part, and we prophesy in part. But when that which is perfect is come, then that which is in part shall be done away. When I was a child, I spake as a child, I understood as a child, I thought as a child, but when I became a man, I put away childish things. For now we see through a glass, darkly, but then face to face, now I know in part, but then shall I know even as also I am known. And now abideth FAITH, HOPE, CHARITY, these three, but the greatest of these is CHARITY.

i Corinthians XIII

2. EDWARD JOHNSTON (1872–1944) Ditchling, England
1 Corinthians XIII, ca. 1920s
Broad-edge pen, writing in blue, red, and black on vellum, decorated initial

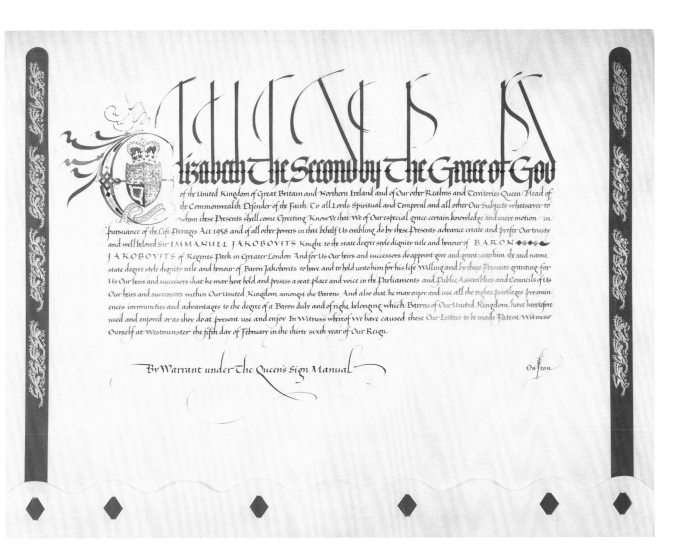

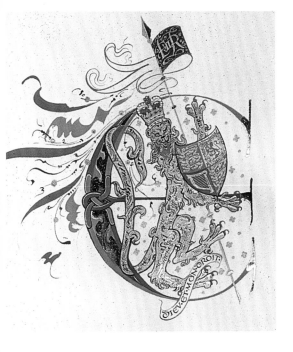

above

3. DONALD JACKSON Monmouth, Wales
Letters Patent
Quills, gouache, calfskin vellum, raised and
burnished gold on gesso, powder gold

left

4. DONALD JACKSON Monmouth, Wales
Trial design initial for E
Quills, gouache, calfskin vellum, raised and
burnished gold on gesso, powder gold

5. MARSHA BRADY Los Alamitos, CA

Koch and Massey On Letters, 1986

Brause nibs, black gouache, Arches 140# hot-press paper, Perma Draft colors, patent gold

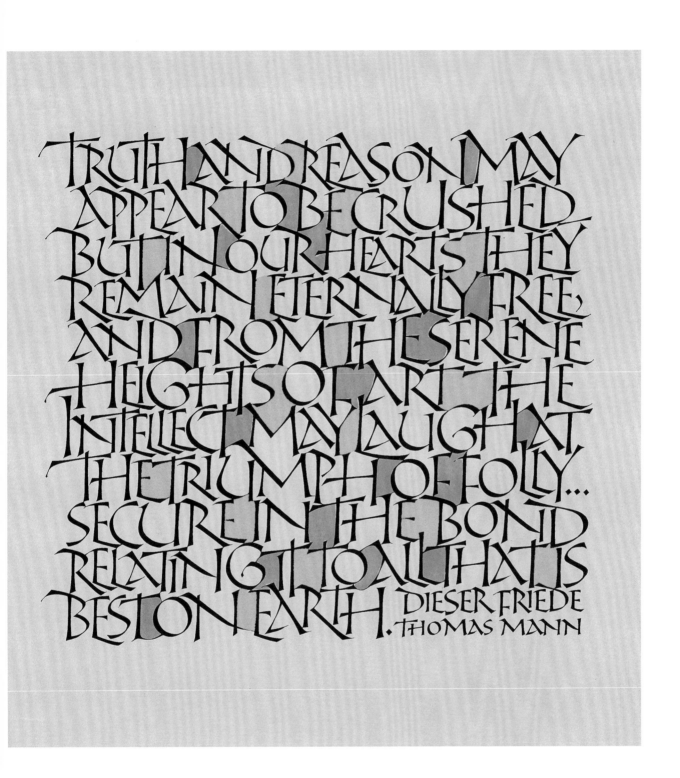

6. ISMAR DAVID (1910–1996) New York, NY
Dieser Friede, [n.d.]
Hand-colored offset print

Song Cycle by Robert Schumann

A WOMAN'S LOVE AND LIFE

on Eight Poems by Adelbert von Chamisso

Vincent FitzGerald & Company
New York 1989

7. JERRY KELLY New York, NY

A Woman's Love and Life, 1989

Letterpress and offset printed on Richard de Bas handmade paper from original broad-edge pen calligraphy

THE ART AND CRAFT OF LETTERING

THE LETTERER PUSHES THE PUDDLES OF INK·NOW VERY WET·NOW VERY DRY· IN THE BEST WAY HE CAN.

HE LETS THE WORLD CALL IT CALLIGRAPHY OR LETTERING, LOOSE OR TIGHT· WRITTEN OR BUILT-UP· CREATIVE OR SLAVISH·AS IT PLEASES. HE IS ONLY CONCERNED WITH MAKING BEAUTIFUL FORMS AND ARRANGING THEM WELL.

ARNOLD BANK

8. ALICE KOETH New York, NY
The Art and Craft of Lettering (original writing for printed production), 1979
Speedball C-nibs, Pelikan fount India ink, 3-ply Strathmore paper, gouache

9. JULIAN WATERS
Gaithersburg, MD
Littera Scripta Manet, 1984
Handmade brass folded
poster pens, Speedball nib,
watercolors, watercolor
paper

HÆC OLIM
MEMINISSE
JUVABIT &

LITTERA
SCRIPTA
MANET

THE CLEAR
REALITIES of NATURE
SEEN WITH THE
INNER EYE OF
the SPIRIT
REVEAL THE ULTIMATE
ECHO of GOD.

ANSEL ADAMS

12. RICHARD LIPTON Milton, MA
Spirit, 1994
Speedball pens, Higgins Eternal ink, Roma handmade paper

13. EMILY BROWN SHIELDS Long Island City, NY
Lines I Like, 1986
Printed book (original written with broad-edge pens, ink, paper)

14. **RUDOLF KOCH (1876–1934)** Offenbach, Germany
Page from *Das ABC Büchlein*, 1934
Calligraphy cut in wood and metal by Fritz Kredel and Gustav Eichenauer and printed letterpress by Koch's son, Paul

15. **HERMANN ZAPF** Darmstadt, Germany
Page from *Pen & Graver*, 1939–40
Letterpress-printed from plates hand-engraved by August Rosenberger

16. HERMANN ZAPF Darmstadt, Germany
Page from *Pen & Graver*, 1939–40
Letterpress-printed from plates hand-engraved by August Rosenberger

17. WARD DUNHAM San Francisco, CA
Buzz Saw Gothic, 1999
Printed (original art with 5mm Brause nib, Chinese stick ink, butcher paper)

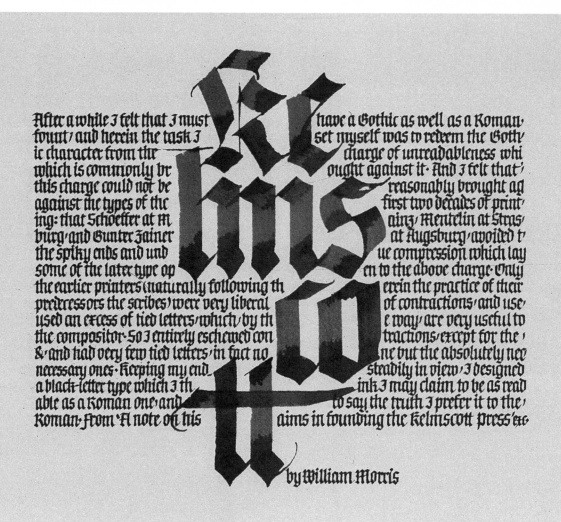

18. LOTHAR HOFFMANN Carsonville, MI
Kelmscott, 1983
Steel brush and Soennecken steel nib, Dr. Martin's dyes, color ink, black ink, Canson paper

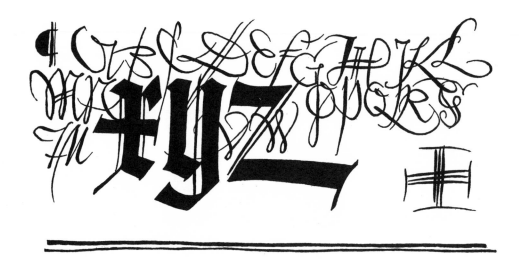

19. RUDOLPH KOCH

Page from *Das ABC Büchlein*, 1934
Calligraphy cut in wood and metal by Fritz Kredel and Gustav Eichenauer and printed letterpress by Koch's son, Paul

What needs my Shakespeare
for his honourd bones
The labour of an age in piled stones
Or that his hallowed relics
should be hid
Under a star-y-pointing pyramid?

DEAR SON OF MEMORY,
GREAT HEIR OF FAME,

What needs thou such weak
witness of thy name?
Thou in our wonder and
astonishment
Hast built thyself
a live-long monument.

JOHN MILTON ON SHAKESPEARE

20. BARRY MORENTZ New York, NY
John Milton on Shakespeare, 1993
Rexel nibs, gouache, Fabriano Italia paper, gesso, gold leaf

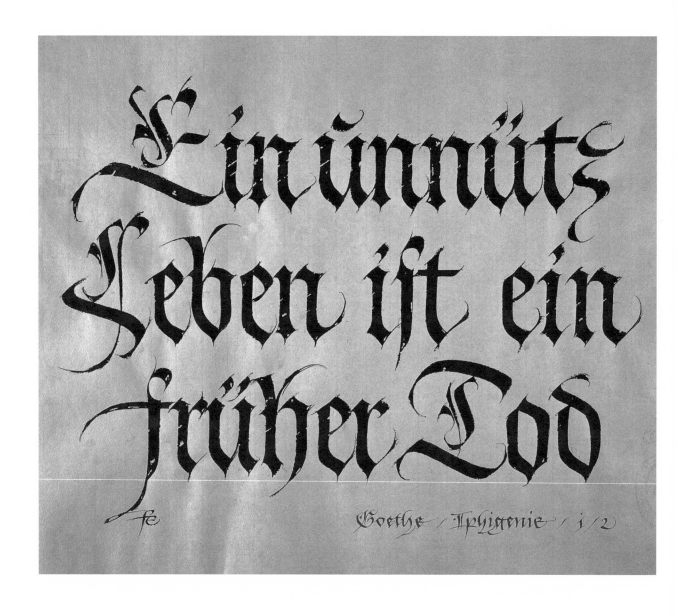

21. FRITZ EBERHARDT (1917–1997) Philadelphia, PA
Goethe Quote (translation: A useless life is an early death), [n.d.]
Original calligraphy on handmade paper

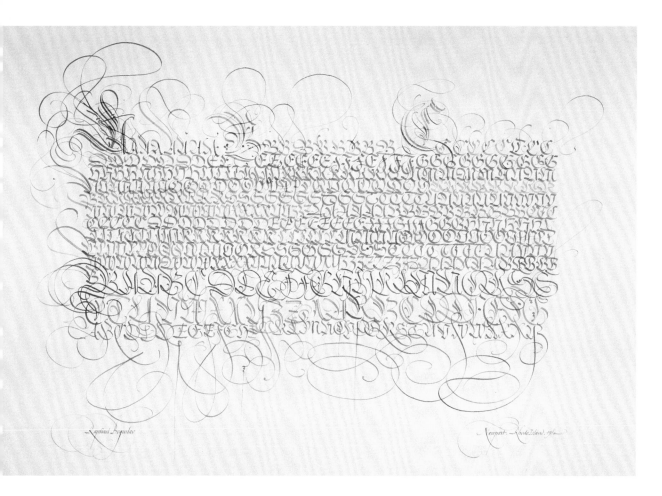

22. RAPHAEL BOGUSLAV Newport, RI
Fraktur capitals exemplar, 1982
Calligraphic fountain pens, various colors of ink

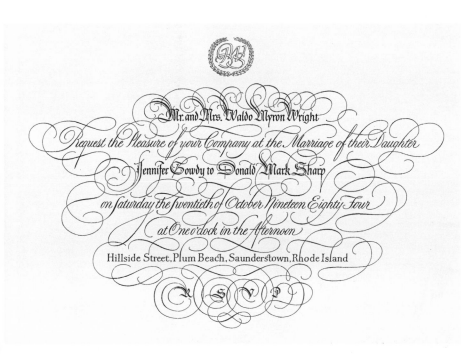

23. RAPHAEL
BOGUSLAV
Newport, RI
Wedding Invitation, 1984
Original written with
calligraphic fountain pen

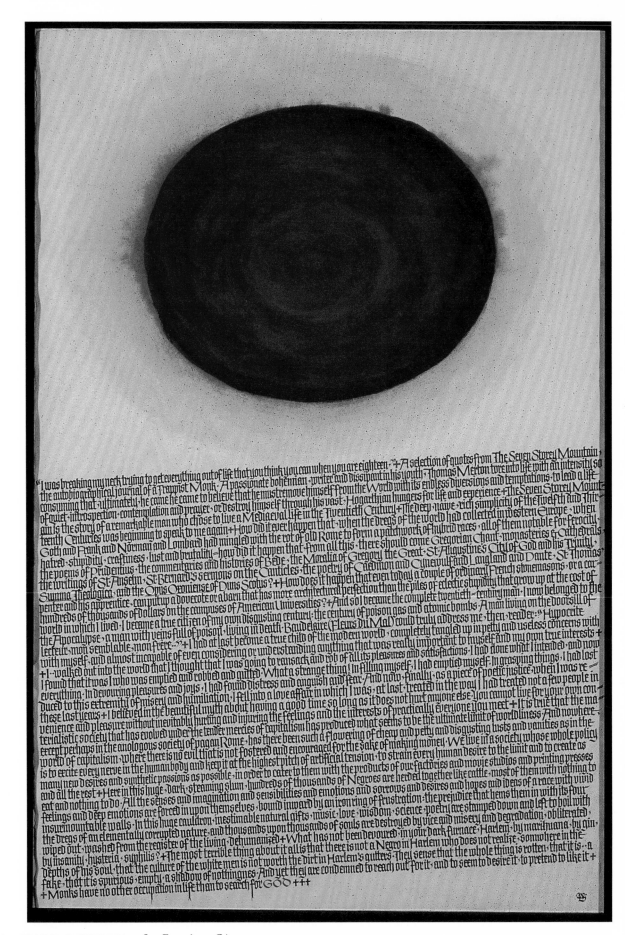

24. **WARD DUNHAM** San Francisco, CA

Thomas Merton, [n.d.]

Steel nib, black Chinese ink, red Chinese stick vermilion, red wine (imported), various gouaches, cadmiums, alizarin crimson, Havana lake, a bit of egg yolk, Nideggan paper

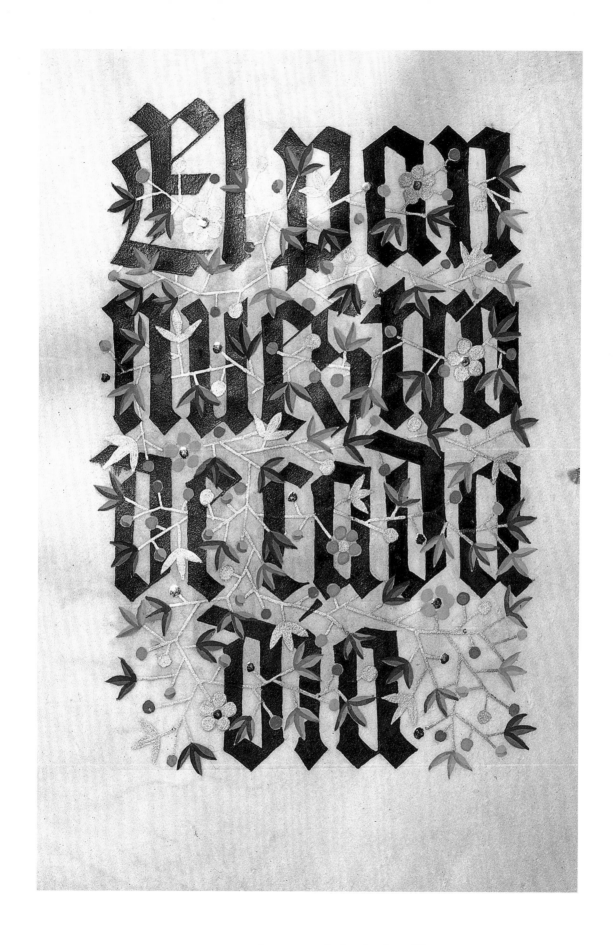

25. GUILLERMO RODRIGUEZ-BENITEZ (1914–1989) San Juan, PR
Padre Nuestro, [n.d.]
Chinese stick ink, gouache, calfskin vellum, shell gold, powder gold, burnished gold leaf on raised gesso

ALIYAH

THE PEOPLES OF ISRAEL

עליה

HOWARD MORLEY SACHAR

ISRAEL TODAY AS SEEN IN THE LIVES OF FIFTEEN MEN
AND WOMEN WHO SHARED IN THEIR COUNTRY'S REBIRTH

26. LILI WRONKER Jamaica, NY
Aliyah, [n.d.]
Printed (original: broad-edge nibs, paper)

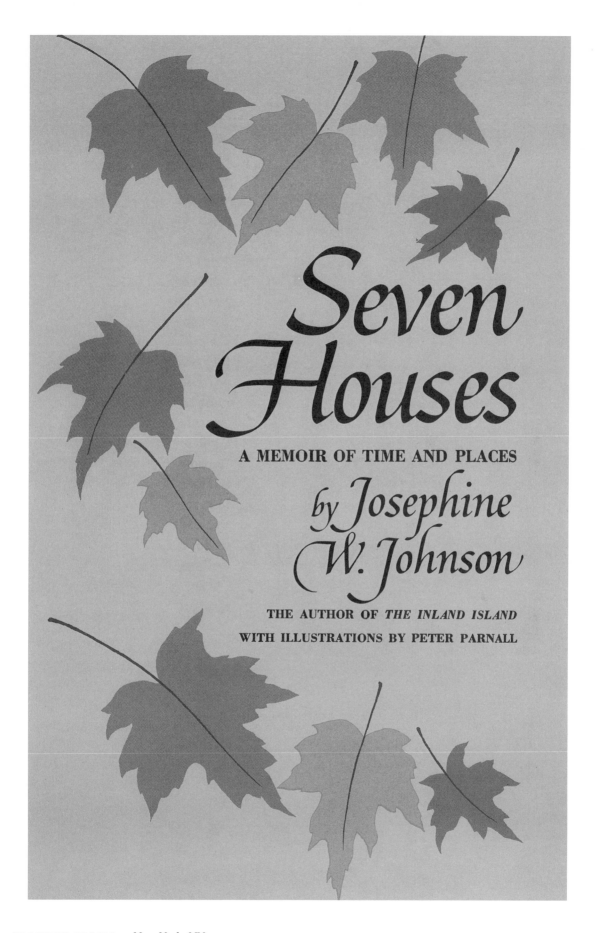

Seven Houses

A MEMOIR OF TIME AND PLACES

by Josephine W. Johnson

THE AUTHOR OF *THE INLAND ISLAND*

WITH ILLUSTRATIONS BY PETER PARNALL

27. JEANYEE WONG New York, NY
Seven Houses, 1973
Printed book jacket (original: manuscript pen, crowquill pen, white Strathmore paper)

"She can write about anything better than anyone else can write about anything."
The New York Times

NORA EPHRON

28. DAVID GATTI Huntington, NY
Nora Ephron Collected, 1987
Mars technical pen, brush, India ink on Strathmore bristol, two-ply plate finish

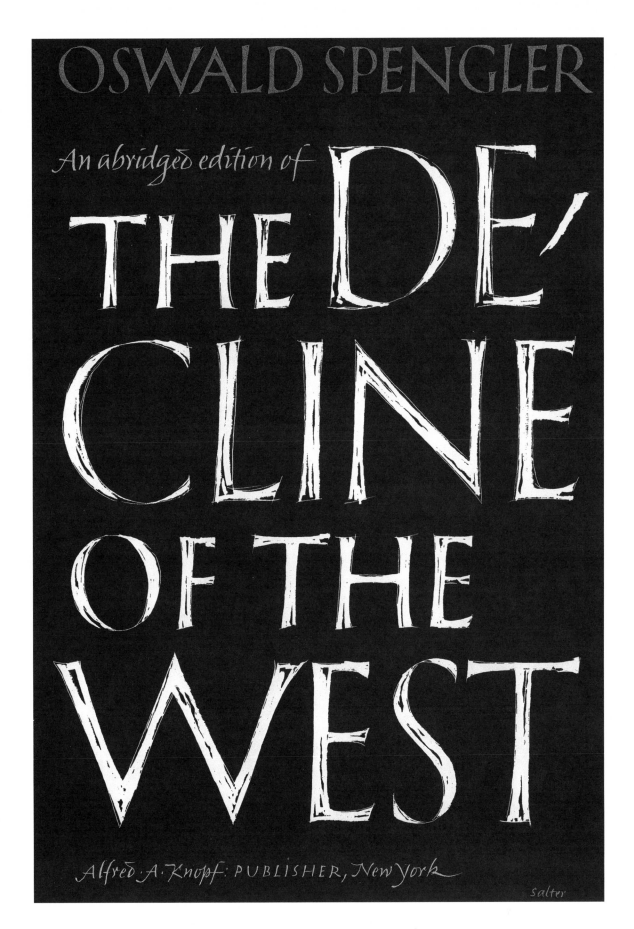

29. GEORGE SALTER (1897–1967)　New York, NY
The Decline of the West, [n.d.]
Printed book jacket

30. JOHN HOWARD
BENSON (1901–1956)
Newport, RI
The First Writing Book, 1955
Offset-printed from Benson's
calligraphy

31. GEORGE SALTER New York, NY
Letterhead for Book Jacket Designers' Guild, [n.d.]
Offset-printed

Arrighi's
Running Hand

A Study of Chancery Cursive
Including a Facsimile of the
1522 "Operina"
with side by side translation

& an Explanatory Supplement
to help Beginners
in the Italic Hand

Paul Standard

32. PAUL STANDARD
(1896–1992)
New York, NY
Arrighi's Running Hand, 1979
Printed book jacket (original: broad-edge pen and ink)

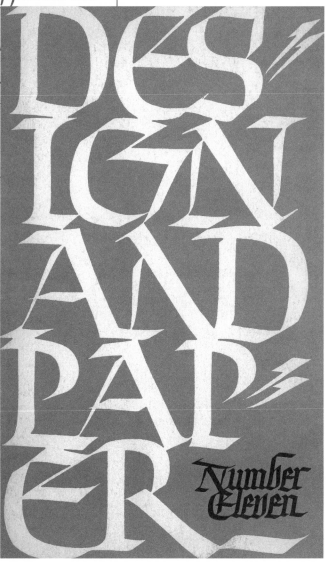

33. OSCAR OGG (1908–1971)
Design & Paper #11, [n.d.]
Printed promotional book

34. DON KUNZ New York, NY
Bastarda Chart, 1967
Broad-edge nibs, ink, paper

Thank you, Don Kunz~nanbncndnc

7423 SE 31 · Portland, OR
9 7 2 0 2

Dear Don, you rascal!
Thank you! Now I have
to do some pen work for
you! However, thanks.
Tomorrow I fly to Texas, to
lecture in the art museum
at Beaumont — at the state
University in Austin.
Ah, those books. What a come-
down since the 1500's &
1600's! They make my hand
ache for the pen.

1·27 Yours, Lloyd 1976

Thank you, Don~nsntn

35. LLOYD REYNOLDS (1902–1978) Portland, OR
Personal correspondence, 1976
Black and vermilion ink on laid writing paper

Time is a cunning thief, beware,

HE PICKS YOUR POCKET DAILY,

NOT AN OLD GREYBEARD, BENT WITH CARE

BUT A YOUNGSTER GRINNING GAILY.

THE GLASS AND SCYTHE ARE MERE DISGUISE

TO COVER HIS QUEER BEHAVINGS,

AND YOU FIND AT LAST WITH SUDDEN SURPRISE

HE HAS STOLEN ALL YOUR SAVINGS.

BUT WHEN THIS HAPPENS, THE THING TO DO

IS NOT TO BEG OR BORROW,

BUT WITH DEFTER FINGERS RIFLE HIM TOO,

AND STEAL ANOTHER TOMORROW.

"TIME IS A CUNNING THIEF" / JAMES T. SHOTWELL

36. MAURY NEMOY Los Angeles, CA
Time is a Cunning Thief, [n.d.]
Printed reproduction for *Scriptura* calendar

37. LILI WRONKER Jamaica, NY
A New York ABC (cover, Society of Scribes Journal), 1986
C-2 Speedball nib, Brause 3/4mm nib, black ink, red gouache

We are the
MUSIC MAKERS
We are the dreamers of dreams,
Wandering by lone sea-breakers,
And sitting by desolate streams;
World-losers and world-forsakers,
On whom the pale moon gleams:
We are the movers and shakers of
The world forever it seems.

38. TOM COSTELLO Brookline, MA
Music Makers, 1989
Heintze & Blanckertz nib, Chinese stick ink,
Arches paper, 24k gold leaf, colored pencils

39. VALERIE WEILMUENSTER Joliet, IL
D. H. Lawrence Quotation, 1996
Ink, gouache, shell gold, Pergamenata paper

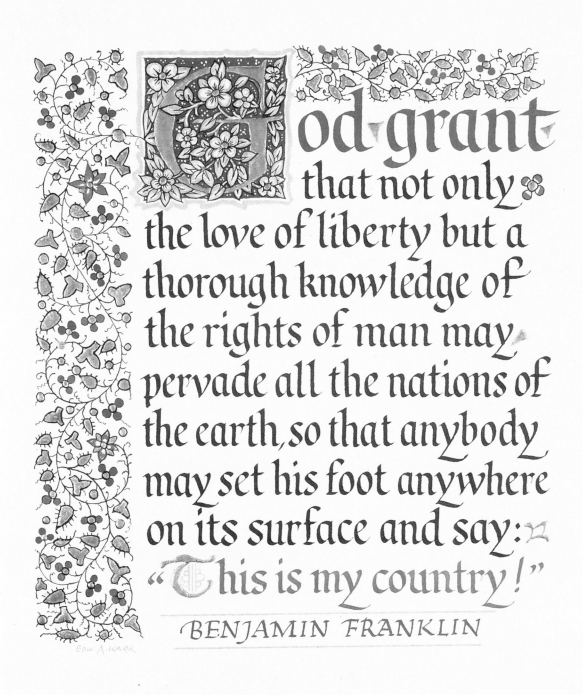

God grant that not only the love of liberty but a thorough knowledge of the rights of man may pervade all the nations of the earth, so that anybody may set his foot anywhere on its surface and say: "This is my country!"

BENJAMIN FRANKLIN

40. EDWARD A. KARR (1909–1997) Brookline, MA
Benjamin Franklin Quotation, ca. 1980
Mitchell nibs, Winsor & Newton brush, stick ink, Winsor & Newton Gouache, Strathmore bristol board, gold leaf

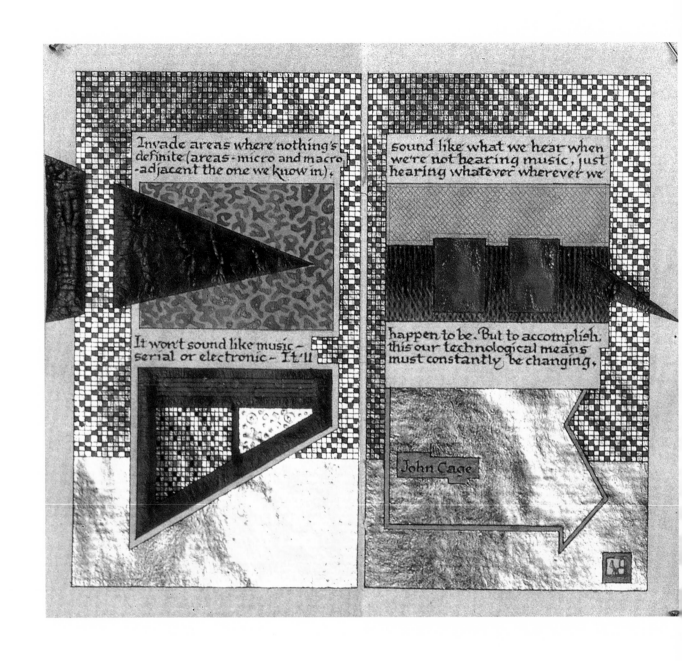

41. BERNARD MAISNER Bay Head, NJ
Invade Areas ... John Cage, 1998
Ink, shell gold on Bodleian cotton/linen blend paper, egg tempera, gold leaf, bound in wood

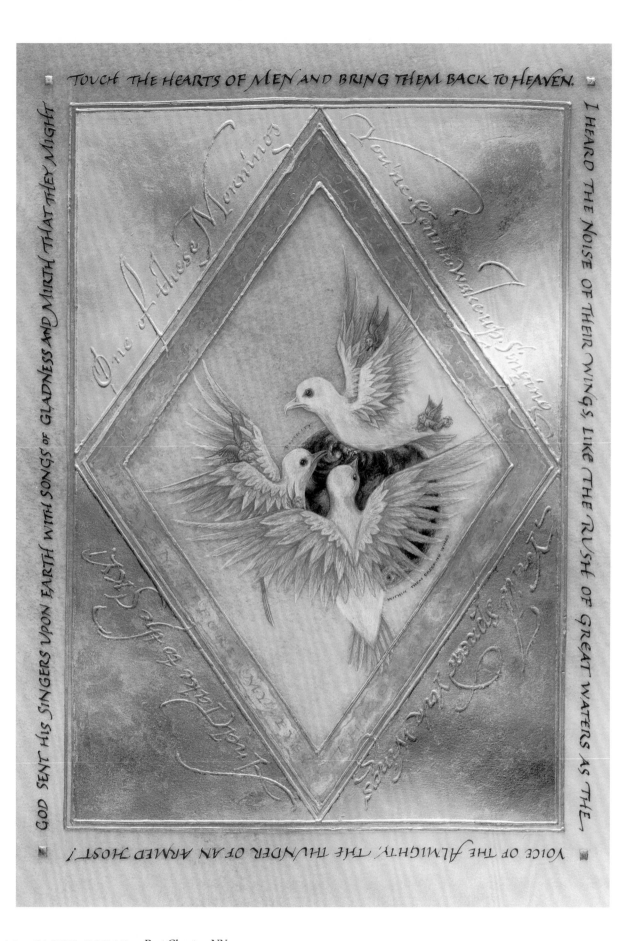

42. **KAREN GORST** Port Chester, NY

Winged Ecstasy, 1999

Lettering with quill, hand-ground gouache: azurite stone, natural indigo, aloe, titanium white, burnt sienna, raised and flat gilding with 22k xxx-deep German leaf, 22k shell gold, gesso applied with ruling pen and quill, calfskin parchment

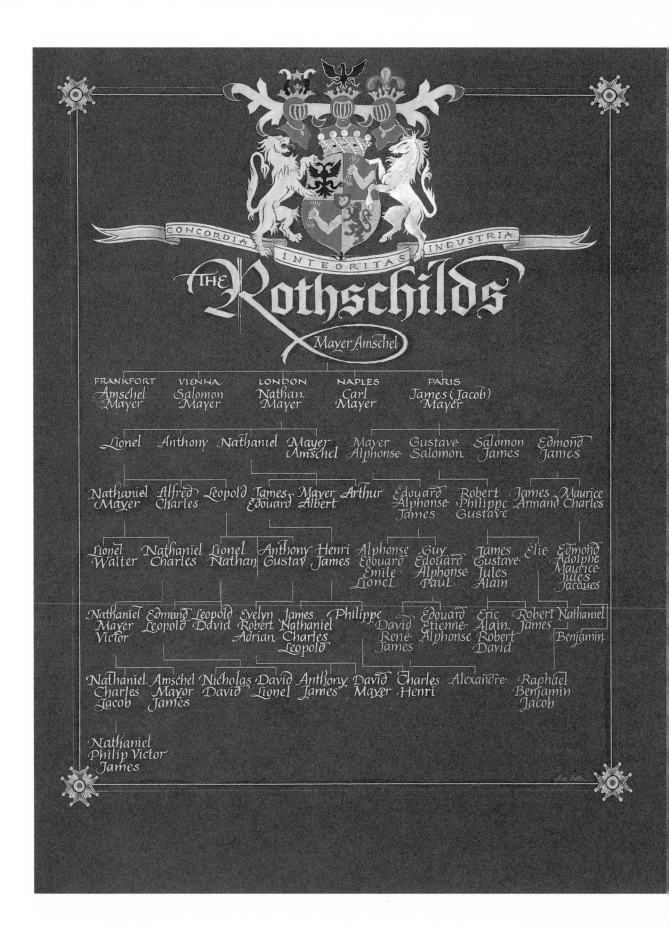

43. INA SALTZ New York, NY

Rothschild Family Tree, 1981

Ruling pen, Winsor & Newton Series 7 sable brushes, Brause nibs, Winsor & Newton gouaches, gold ink, pencil, Canson paper

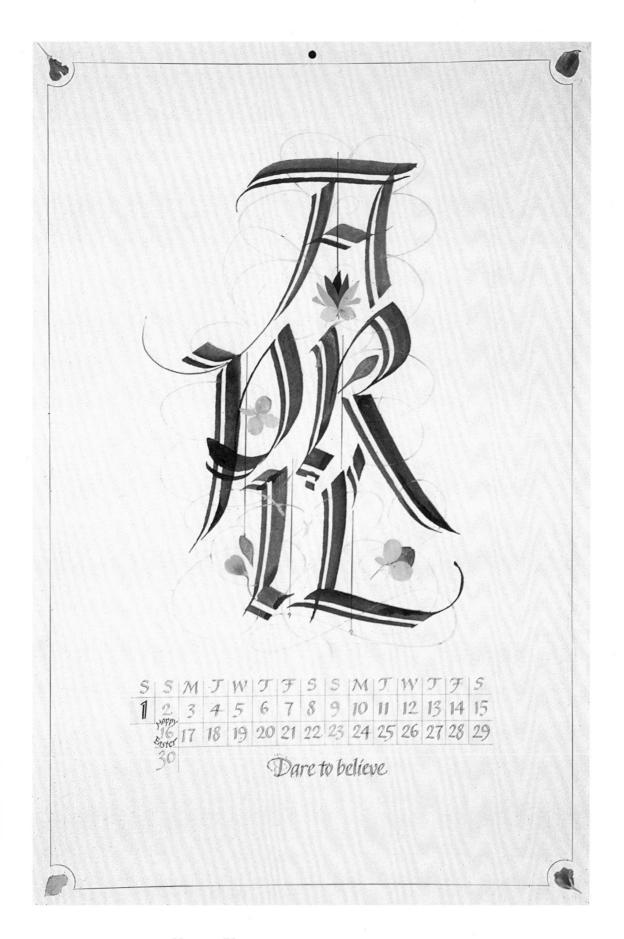

44. **ROBERT BOYAJIAN** Newport, RI
April Wall Calendar, 1995
Lozada split pen and scroll pen, Luma watercolors, illustration board, dried pressed flower petals

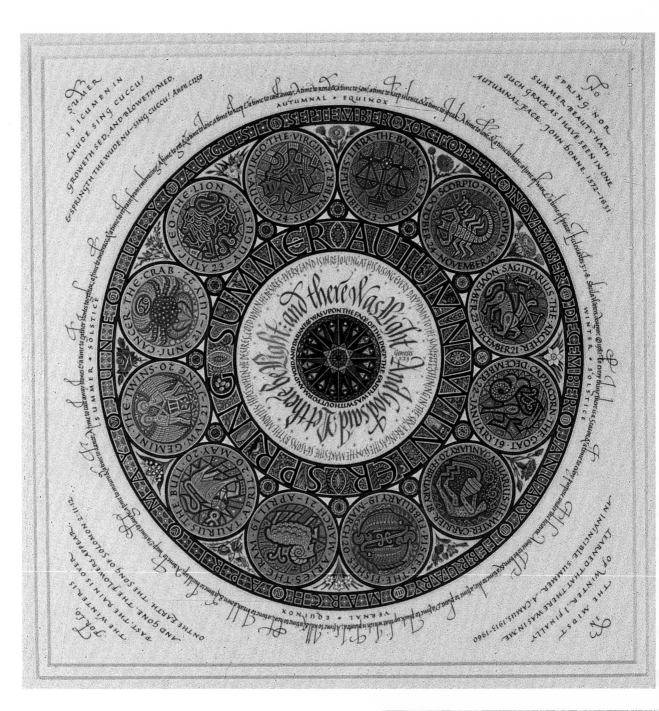

45. **SHEILA WATERS** Fairfield, PA

Roundel of the Seasons, 1981

Steel nibs, watercolor brushes, black Chinese stick ink, gouache
and watercolors, calfskin vellum

46. DONALD JACKSON
Monmouth, Wales
Sketch Book
Studies of various
techniques

47. ROSE FOLSOM Silver Spring, MD
Mozart Again, 1999
Mitchell nibs with gouache on paste-paper
made with wheat paste and vinyl paint on
Twinrocker white cotton rag paper

48. SUZANNE MOORE
Tuscaloosa, AL
Transitional A, 1998
Wrappers: gold stamping on
paste paper, gilding: 23k
gold, vintage Saunders and
Twinrocker papers

*For he is an evil spirit male and female.
Let Keros rejoice with Tree Germander.
For he is called the Duce by foolish invo-
cation on that account. Let Padon rejoice
with Tamnus Black Briony. For Three
is the simplest and best of all numbers.
Let Mizpar rejoice with Stickadore. For
Four is good being square. Let Baanah
rejoice with Napus the French Turnip.
For Five is not so good in itself but works
well in combination. Let Reelaiah re-
joice with the Sea-Cabbage. For Five is
not so good in itself as it consists of two
and three. Let Parosh rejoice with Ca-*

*cubalus Chickweed. For Six is very good
consisting of twice three. Let Hagab re-
joice with Serpyllum Mother of Thyme.
Hosanna to the memory of Q. Anne.
March 8th NS 1761 – God be gracious
to old Windsmore. For Seven is very
good consisting of two compleat num-
bers. Let Shalmai rejoice with Meadow
Rue. – For Eight is good for the same
reason and propitious to me Eighth of
March 1761 hallelujah. Let Habaiah
rejoice with Asteriscus Yellow Starwort.
For Nine is a number very good and har-
monious. Let Tel-harsa rejoice with*

49. SUSIE TAYLOR San Francisco, CA
Selection: "Jubilate Agno", 1994
Mitchell/Rexel nib, Winsor & Newton gouache, Canson Ingres paper, binding: tan linen
Bound by Daniel Flanagan

ERNST FREDERICK DETTERER

NOBLE WORK is a social achievement. It is al~ ways the product of cultural discipline and that is usually developed in a school and transmitted through a trained and talented individual. Such an individual was Ernst F. Detterer.

Since 1919 innumerable workers in graphic design and calligraphy, throughout the American Midwest, have been profoundly influenced by his intellectual and

50. JAMES HAYES (1907–1993) Chicago, IL
Memorial to Ernst Frederick Detterer, ca. 1944 [DETAIL]
Broad edge pen calligraphy reproduced in multiple colors

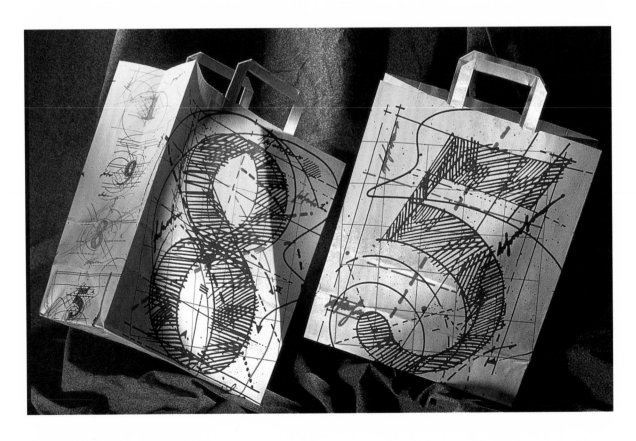

51. TIM GIRVIN Seattle, WA
"85"
Bloomingdale's shopping bag, 1985
Ruling pen, spatter brush, airbrush

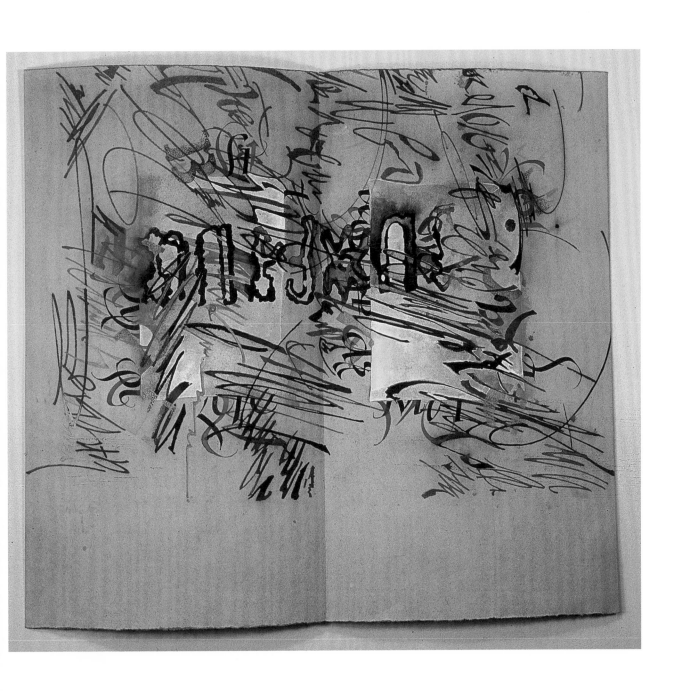

52. SUZANNE MOORE Tuscaloosa, AL

Meanderings, 1999

Pencil, chalk, ink, gouache, acrylics, 23k gold, vintage Saunders, Twinrocker, and Arches papers

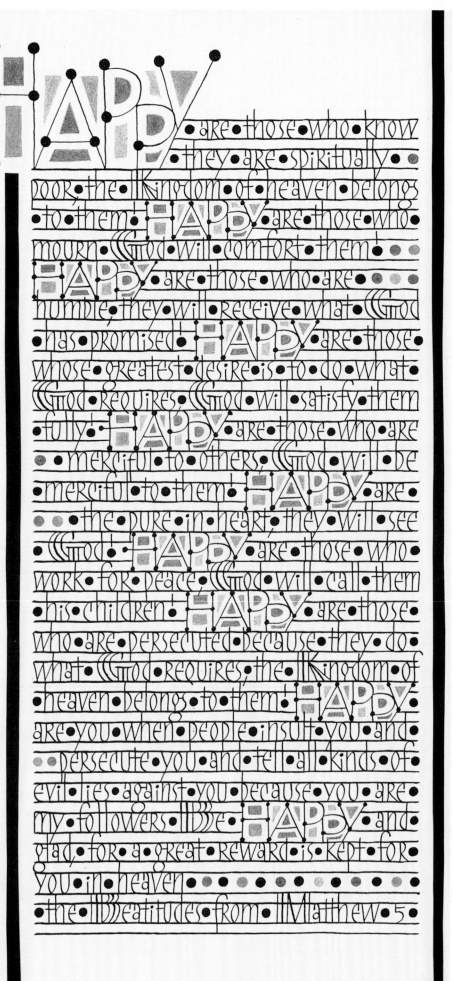

53. EMILY BROWN
SHIELDS
Long Island City, NY
The Beatitudes:
Matthew 5, 1998
Mitchell nibs, Pelikan
fount ink, color pencils,
Somerset Satin paper,
black Fabriano paper

54. **KAREN CHARATAN**
Montvale, NJ
The Best Gifts of All,
1993
Square-edge brushes,
Winsor & Newton
watercolor and
gouache,
Lanaquarelle paper

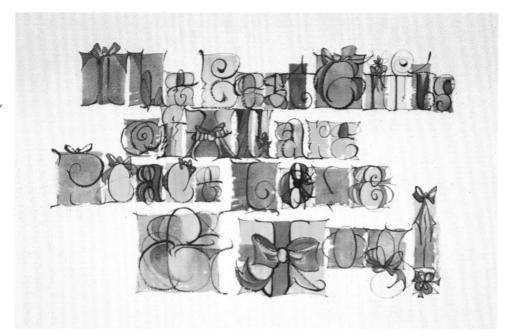

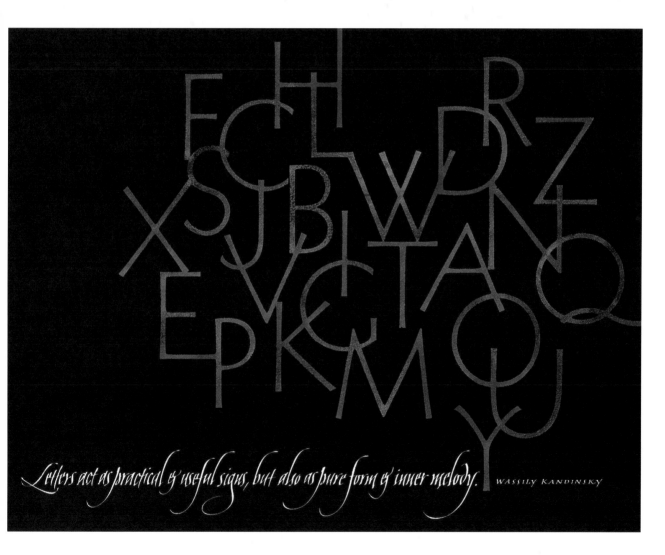

55. **RICK CUSICK** Overland Park, KS
Society of Scribes 10th Anniversary Keepsake, 1984
Offset-printed in 4-color process

The Seventeenth Century in Italy

DRAWINGS
FROM NEW YORK COLLECTIONS, II

Organized jointly by
The Pierpont Morgan Library
& The Metropolitan Museum of Art

FEBRUARY 24 · APRIL 29, 1967

56. MARVIN NEWMAN (1924–1967) New York, NY
The 17th Century in Italy
Exhibition poster for the Morgan Library, 1967
Broad-edge pens, gouache, Strathmore paper

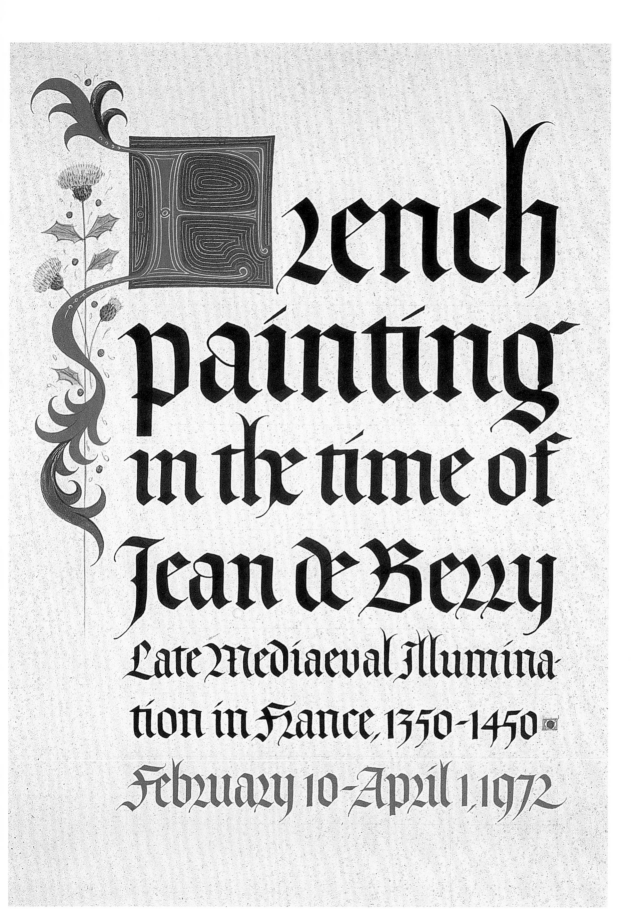

French painting in the time of Jean de Berry

Late Mediaeval Illumination in France, 1350-1450

February 10-April 1, 1972

57. ALICE KOETH New York City
French Painting
Exhibition poster for the Morgan Library, 1972
Coit pens, Speedball nibs, Pelikan fount India ink, 3-ply Strathmore paper, gouache and watercolor, Plaka gold paint

WhEN IN THE COURSE OF HUMAN EVENTS,

it becomes necessary for one people to dissolve the political bands which have connected them with another, and to assume among the powers of the earth the separate and equal station to which the laws of nature and of nature's God entitle them, a decent respect to the opinions of mankind requires that they should declare the causes which impel them to the separation. We hold these truths to be self-evident; that all men are created equal; that they are endowed by their creator with certain unalienable rights; that among these are life, liberty, and the pursuit of happiness; that to secure these rights, governments are instituted among men, deriving their just powers from the consent of the governed; that whenever any form of government becomes destructive to these ends, it is the right of the people to alter or to abolish it, and to institute new government, laying its foundation on such principles, and organizing its powers in such form, as to them shall seem most likely to effect their safety and happiness.

from THE DECLARATION OF INDEPENDENCE

Thomas Jefferson July 4, 1776

58. HERMANN ZAPF Darmstadt, Germany
Declaration of Independence, 1996
Broad-edge nibs, blue, red and black ink, Zerkall mould-made paper

If I were asked to say
what is at once the most important
production of Art and the thing
most to be longed for, I should answer

A BEAUTIFUL HOUSE

and if I were further asked to name
the production next in importance
and the thing next to be longed for
I should answer

A BEAUTIFUL BOOK

To enjoy good houses and good books
in self respect and decent comfort
seems to me to be the pleasurable end
towards which all societies
of human beings WILLIAM MORRIS
ought now to struggle

59. JULIAN WATERS Gaithersburg, MD
William Morris Quotation, 1997
Mitchell nibs, Chinese stick ink, watercolor, Barcham Green handmade paper

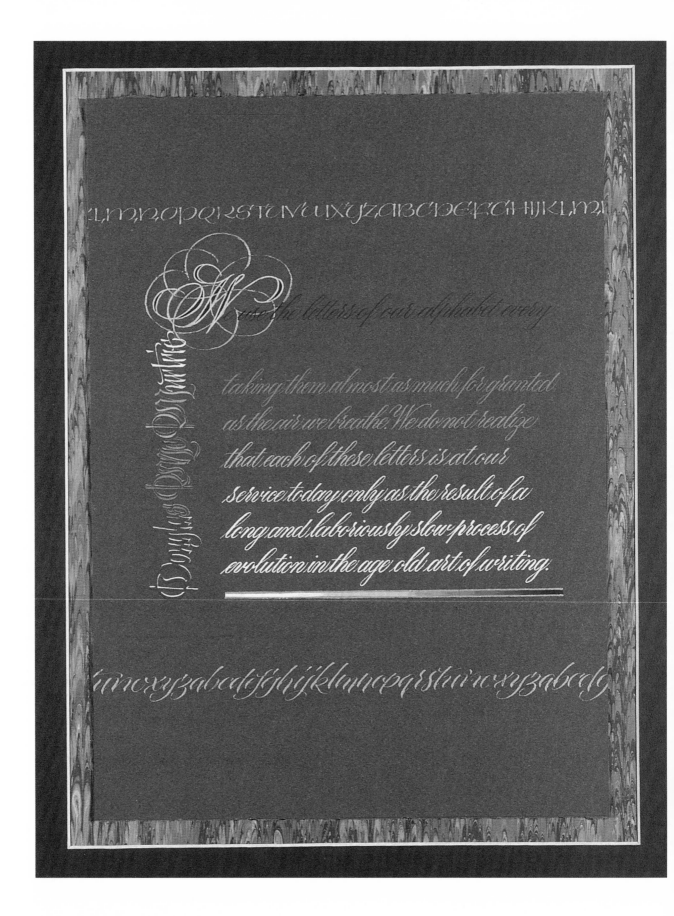

60. MIKE KECSEG Chicago, IL
McMurtrie quotation
Pointed pen, gouache, Canson paper

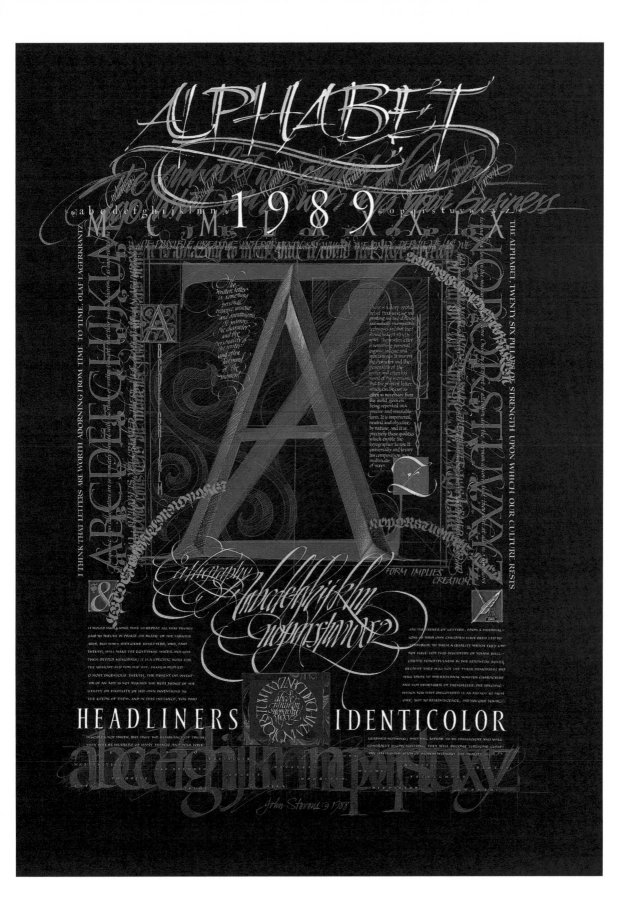

61. JOHN STEVENS Winston-Salem, NC

Alphabet / Headliners, 1988

Broad-edge, pointed, quill and reed pens, broad and pointed brushes, gouache, casein, color pencil, Fabriano paper

62. KAREN CHARATAN Montvale, NJ
Wisdom, 1999
Ruling pen, gouache, Canson paper

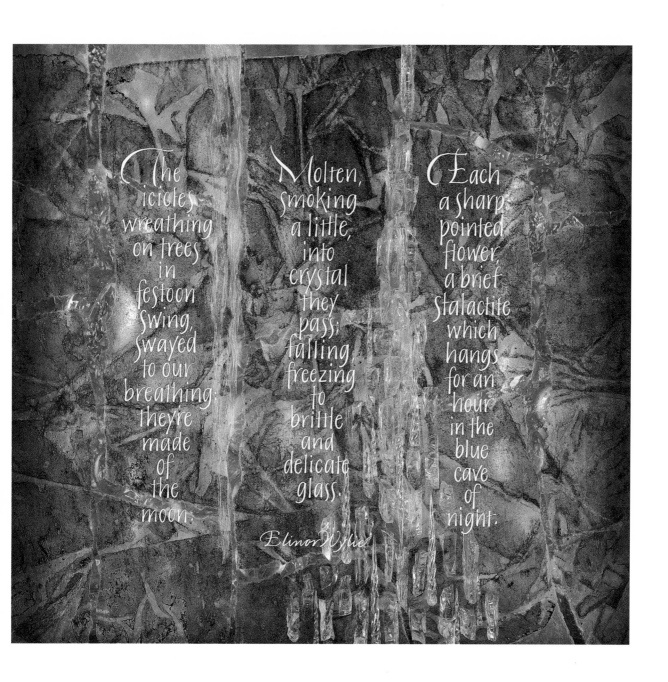

The icicles
wreathing
on trees
in
festoon
swing,
swayed
to our
breathing;
they're
made
of
the
moon:

Molten,
smoking
a little,
into
crystal
they
pass;
falling,
freezing
to
brittle
and
delicate
glass.

Elinor Wylie

Each
a sharp,
pointed
flower,
a brief
stalactite
which
hangs
for an
hour
in the
blue
cave
of
night.

63. CAROLINE PAGET LEAKE Brooklyn, NY
The Icicles, 1999
Pointed pen, India and acrylic inks, wood, glass, plexiglass, acrylic gems, iridescent plastic, wax paper

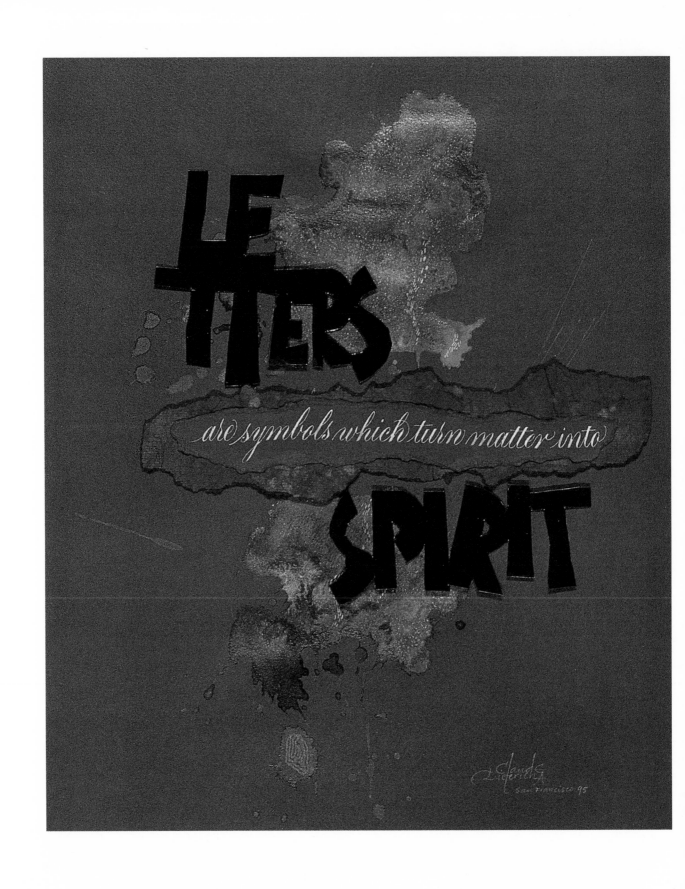

64. CLAUDE DIETERICH San Francisco, CA
Letters Are Symbols, ca. 1992
Collage, ink, watercolor

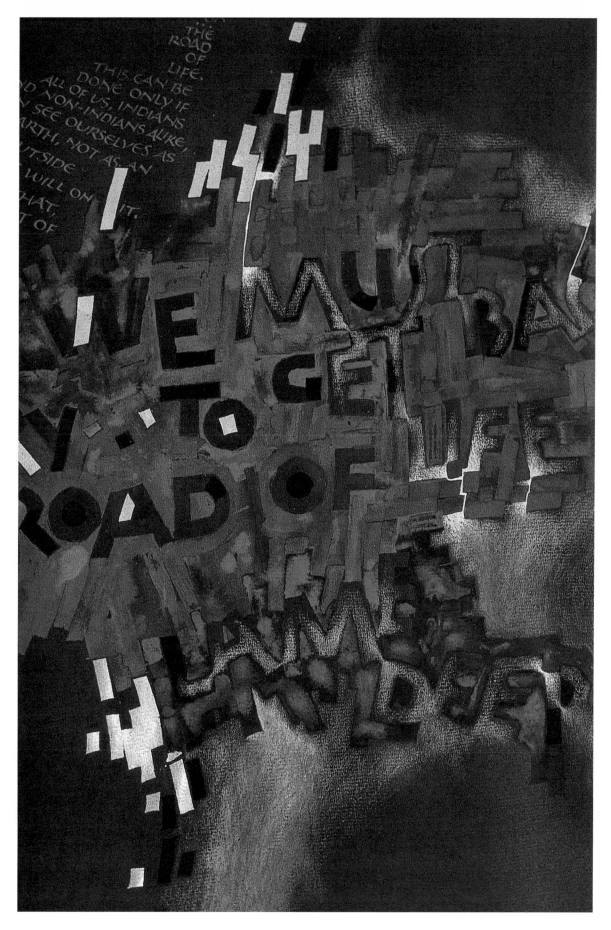

65. NANCY CULMONE Mosquero, NM
Lame Deer Said, 1986
Speedball C-0, turkey quill, Dresden Ingres paper, Winsor & Newton gouache, 23k gold leaf on ammoniac,
Derwent colored pencils

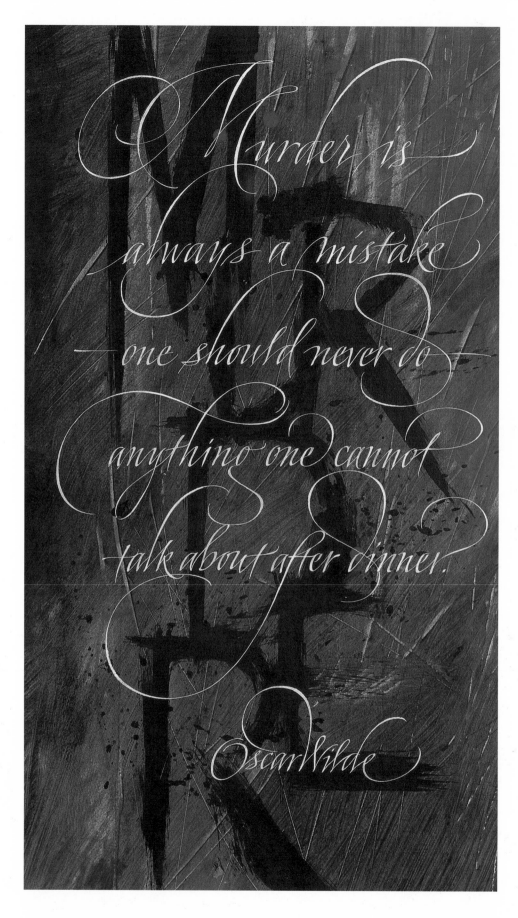

66. JOHN STEVENS Winston-Salem, NC
Murder, 1996
Broad-edge pen, gouache, acrylic, Arches paper, wheat paste, acrylics, knives

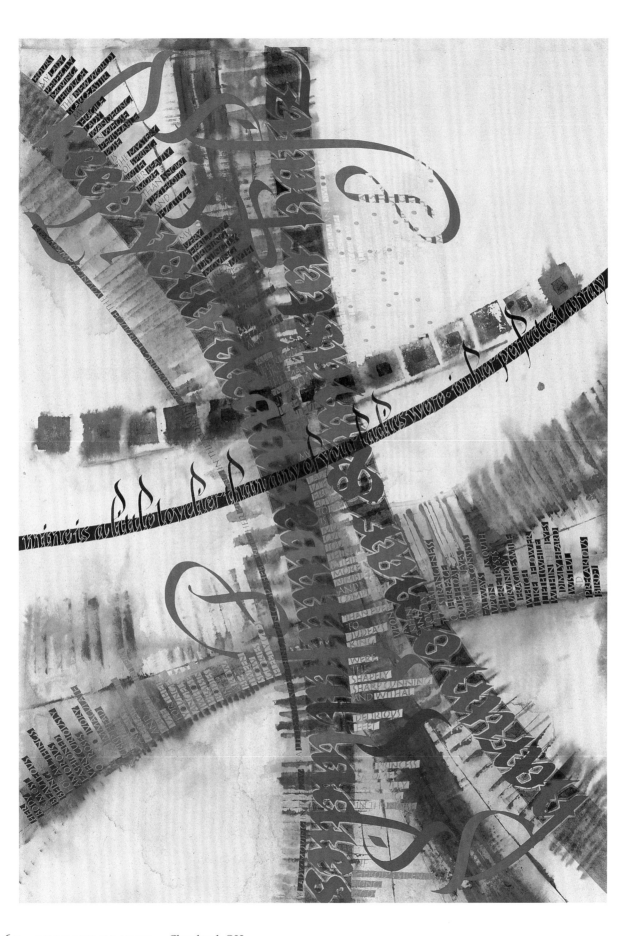

67. CHARLES PEARCE Cleveland, OH
Puella Mea, [n.d.]
Broad-edge nibs, gouache and watercolor, Arches hot-press watercolor paper

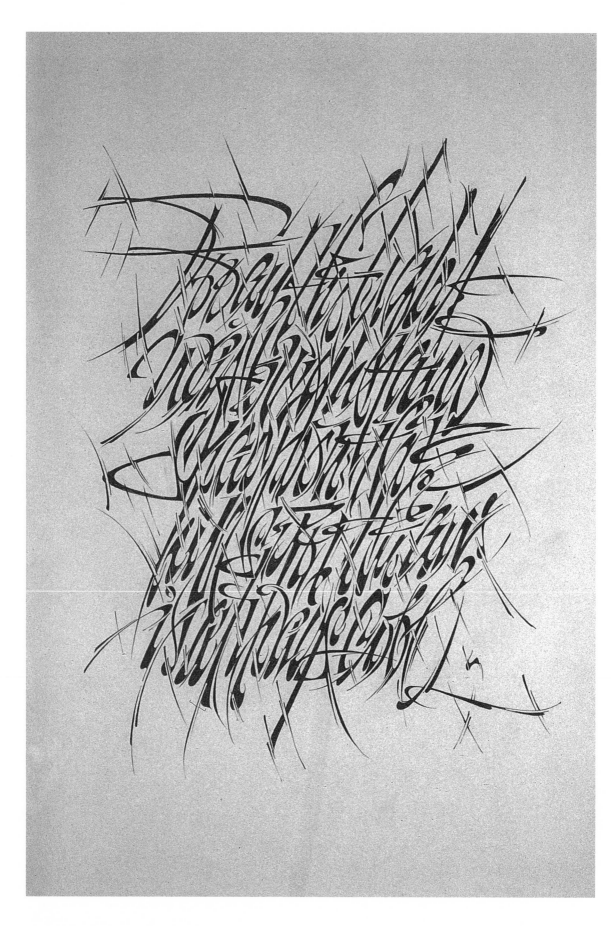

68. CARL E. KURTZ Excelsior Springs, MO
Today the Light ..., 1998
Graphite pencil, watercolor paper

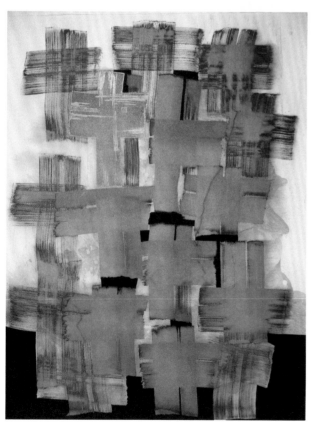

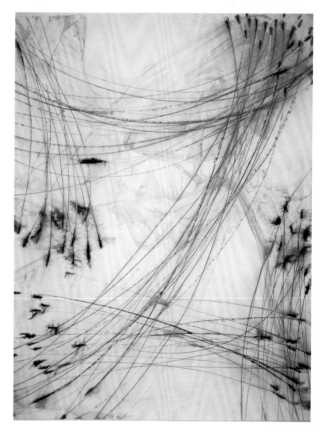

69. SUSAN SKARSGARD Ann Arbor, MI
Alphabetic Fiction (A, S, T, Z from a series), 1993
Ink, gouache, gold leaf, gesso, Arches text wove paper

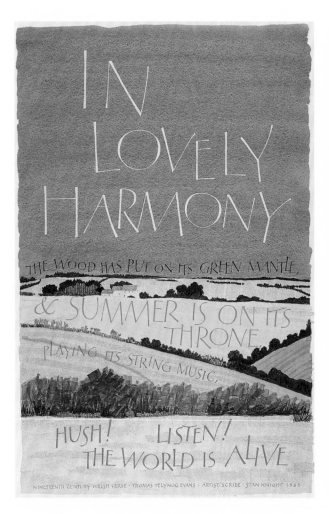

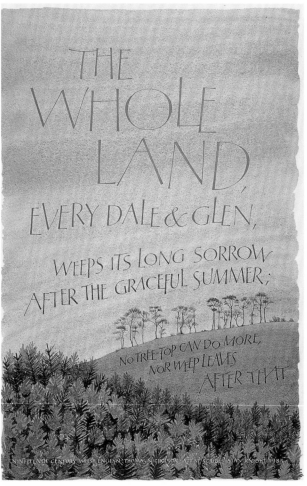

70. **STAN KNIGHT** Harrison, ID

The Four Seasons: Spring, Summer, Autumn, Winter, 1985

Mitchell pens, Winsor & Newton Series 7 brushes, T. H. Saunders cold press paper, watercolor, resist

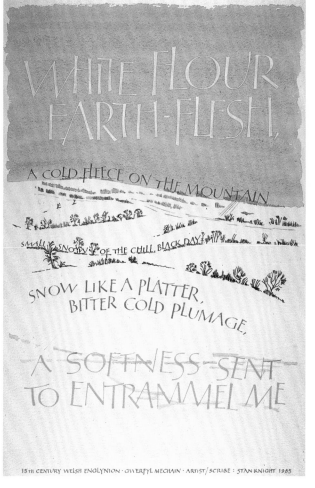

15TH CENTURY WELSH ENGLYNION · GWERFYL MECHAIN · ARTIST/SCRIBE : STAN KNIGHT 1985

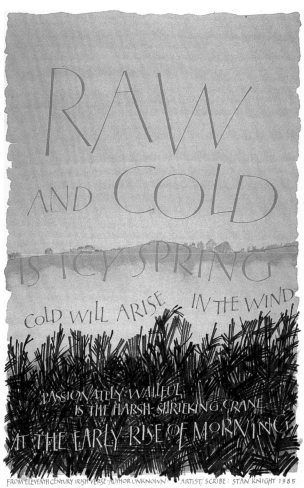

FROM ELEVENTH CENTURY IRISH VERSE · AUTHOR UNKNOWN · ARTIST/SCRIBE : STAN KNIGHT 1985

71. **ALEXANDER ZANETTI** East Brunswick, NJ
A–Z, 1988
Signwriters' quill ferrule brush, gouache, tempera, black paper

72. **CARL ROHRS** Santa Cruz, CA
Bebop, 1997
Photographic transfer process, glue-chipped glass, gold leaf and abalone (original calligraphy: dog-hair brush, background calligraphy: pointed brush, gouache, black mat, marbled paper)

RSTUVWXY

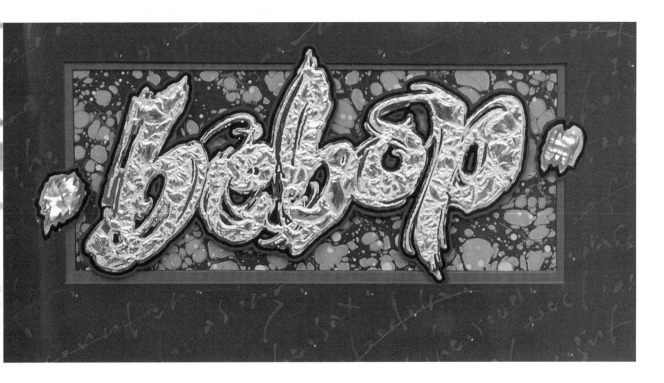

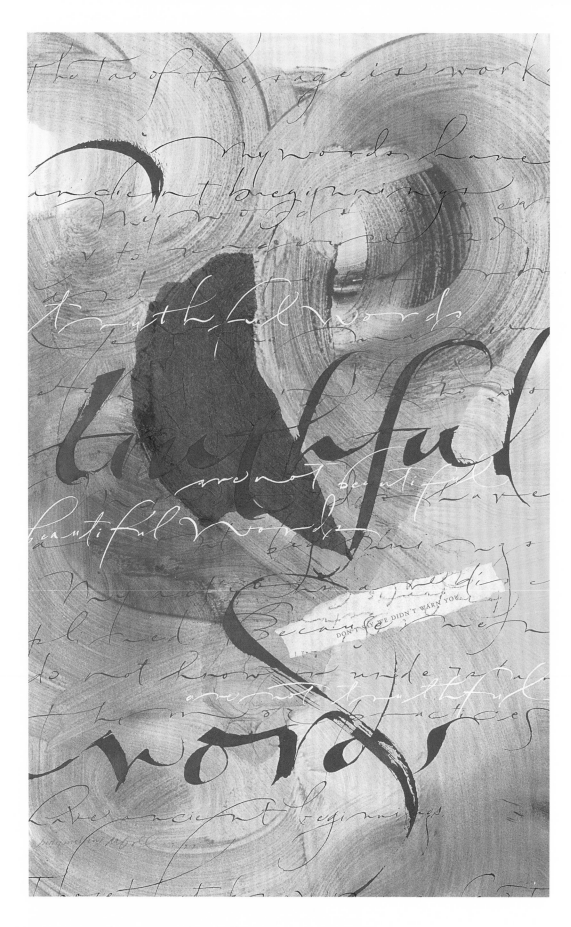

73. MICHAEL GOLD / JUDY MELVIN (collaboration) Bay Village, OH
Truthful Words, 1996
Acrylic and gouache, Arches text wove paper

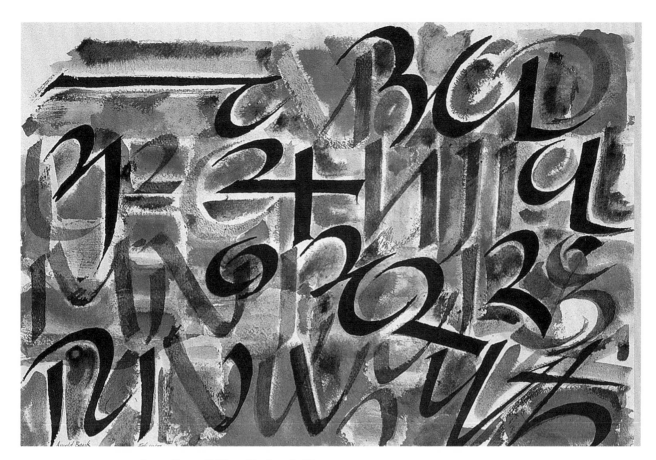

74. ARNOLD BANK (1908–1986) Pittsburgh, PA
Alphabetic Calligraphics, 1967
Flat broad-edge brushes, black and gray ink, watercolor, watercolor paper

75. ELEANOR WINTERS
Brooklyn, NY
First Light
Calligraphy quilt collage, 1998
Brause nib, gouache, marbled
papers, Japanese papers

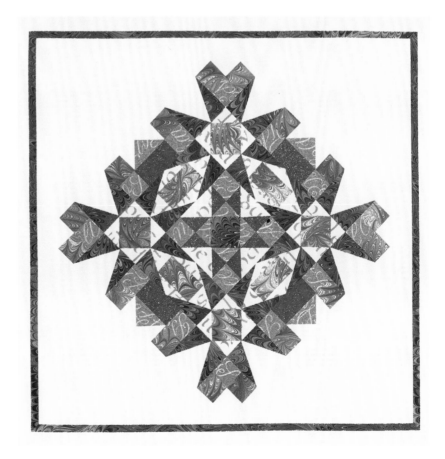

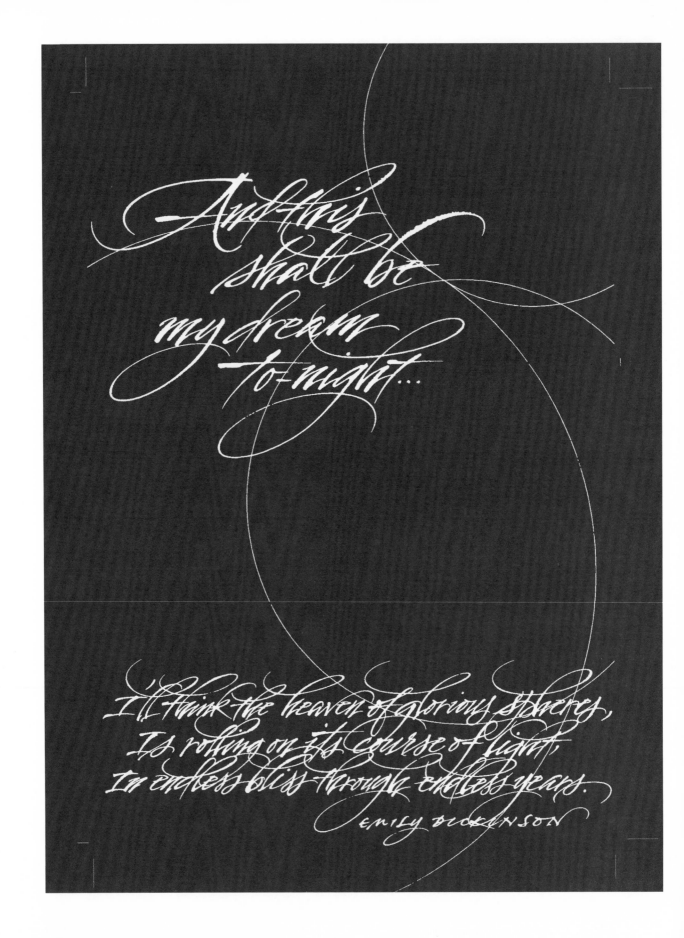

76. RICK CUSICK Overland Park, KS
…My Dream To-night (poster), 1996
Ruling pen, ink, paper

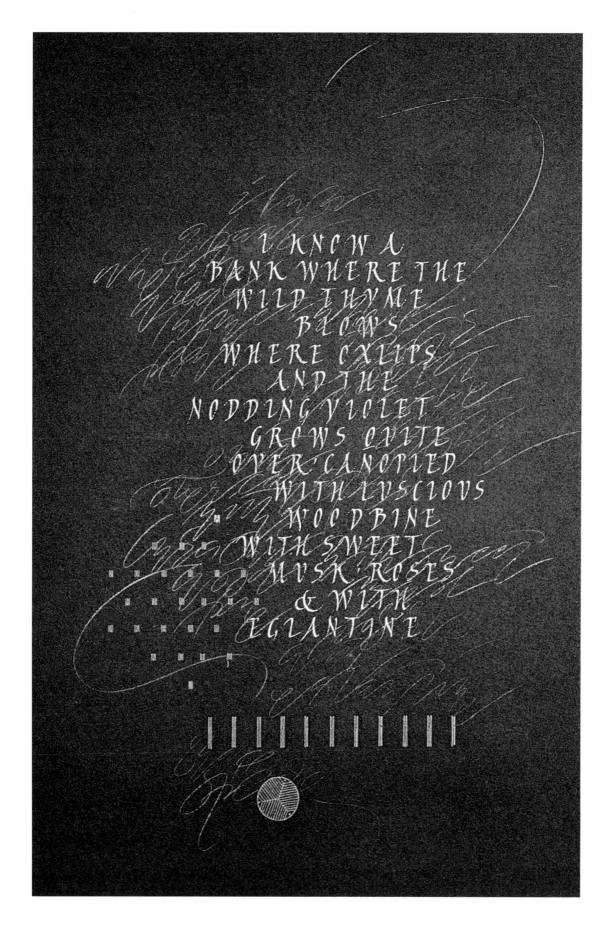

77. GEORGIA DEAVER San Francisco, CA
I Know a Bank, ca. 1990
Broad-edge pen, ruling pen, gouache, Sennelier pastel paper, shell gold

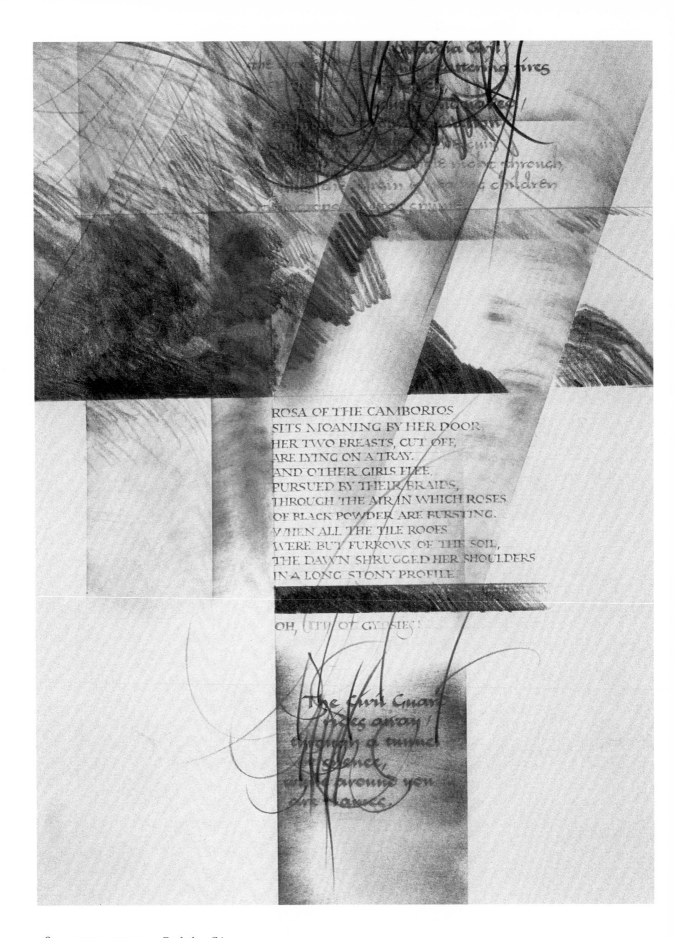

ROSA OF THE CAMBORIOS
SITS MOANING BY HER DOOR,
HER TWO BREASTS, CUT OFF,
ARE LYING ON A TRAY.
AND OTHER GIRLS FLEE,
PURSUED BY THEIR BRAIDS,
THROUGH THE AIR IN WHICH ROSES
OF BLACK POWDER ARE BURSTING.
WHEN ALL THE TILE ROOFS
WERE BUT FURROWS OF THE SOIL,
THE DAWN SHRUGGED HER SHOULDERS
IN A LONG STONY PROFILE.

OH, CITY OF GYPSIES!

78. ARNE WOLF Berkeley, CA
The Ballad of the Spanish Civil Guard [DETAIL], 1980
Pencil, color pencil, soft pastels, eraser, German drawing paper

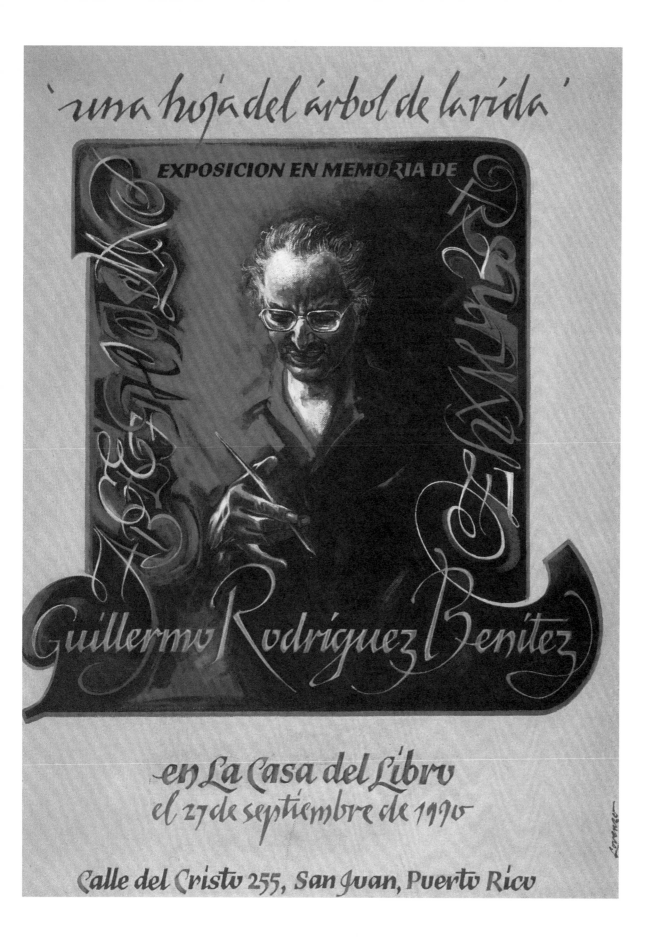

79. LORENZO HOMAR San Juan, PR
Guillermo Rodriguez-Benitez in Memorial, 1990
Offset-printed poster (original painting in acrylics)

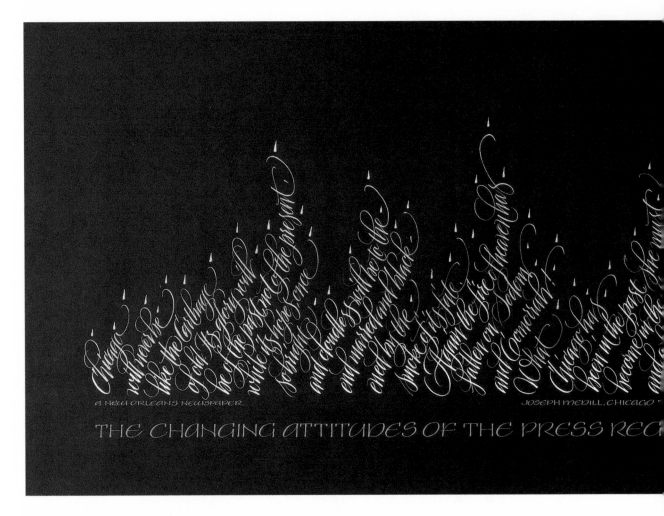

80. MIKE KECSEG Chicago, IL
The Chicago Fire, 1989
Pointed pen, gouache, Canson paper

81. JEAN EVANS Cambridge, MA
NYNEX Brochure, 1985
Printed in four-color process (original done with automatic pen and 4001 Pelikan ink)

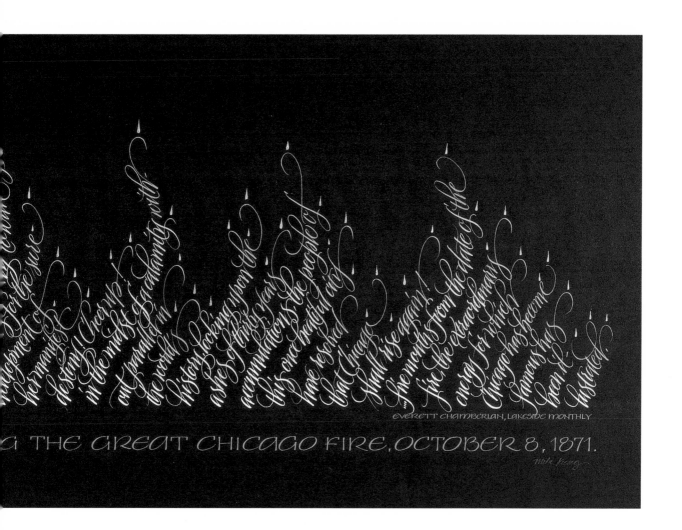

EVERETT CHAMBERLAN, LAKESIDE MONTHLY

G THE GREAT CHICAGO FIRE, OCTOBER 8, 1871.

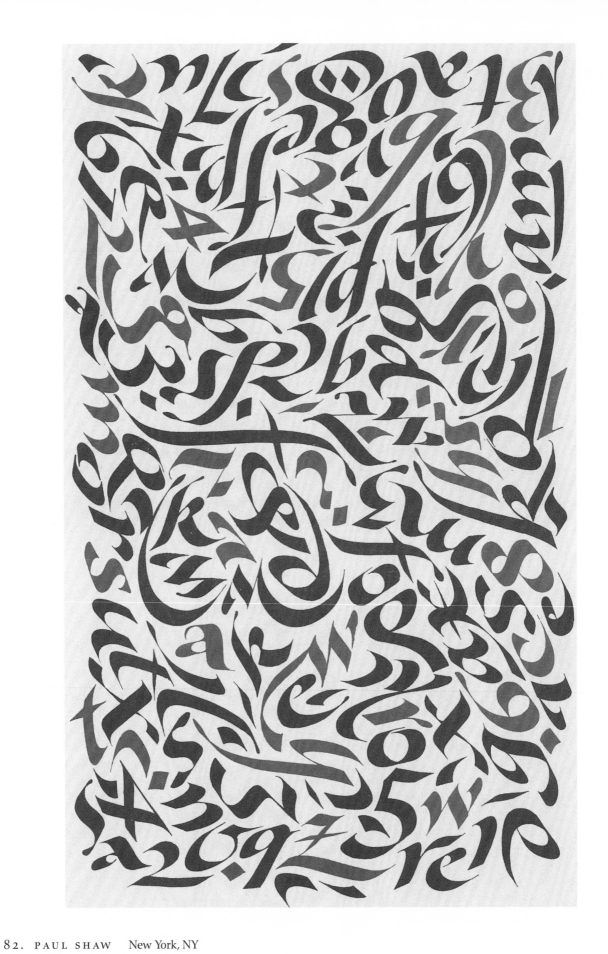

82. PAUL SHAW New York, NY

Alphabet #11, 1993

Letterpress-printed (original with 1/2" Automatic pen, Higgins India ink, Andrews-Nelson-Whitehead paper)

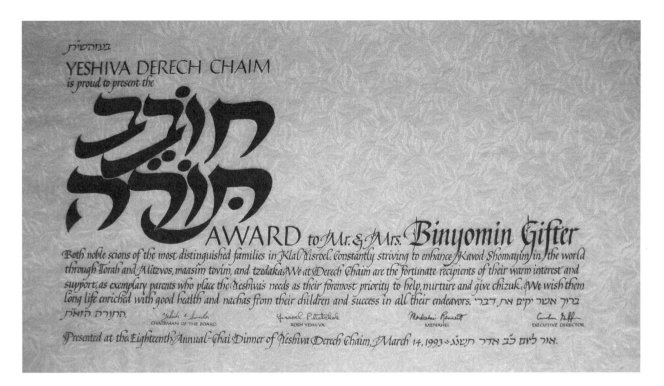

83. TED SIMCHA KADIN Brooklyn, NY

Choveiv Torah Award / Lover of the Torah Award, 1993

Mitchell nibs, Coit pens, Speedball C-series nibs, Winsor & Newton sable brush series 7, sumi ink, acetate film, acrylic panel, Kinwashi-Japanese rice paper

84. DAVID MEKELBURG Los Angeles, CA

Greeting Cards, 1989

Printed cards, 4-color process (originals written with broad-edge pens, ink and watercolor)

IN THE FEW
SECONDS IT TAKES
YOU TO READ THIS
SENTENCE, 24 PEOPLE
WILL BE ADDED TO THE
EARTH'S POPULATION.
BEFORE YOU'VE
FINISHED THIS,
THAT NUMBER WILL
REACH 1000
WITHIN AN HOUR—11,000.
BY DAY'S END—260, 000
BEFORE YOU GO TO BED TWO
NIGHTS FROM NOW, THE NET
GROWTH IN HUMAN NUMBERS
WILL BE ENOUGH TO FILL A CITY
THE SIZE OF SAN FRANCISCO.
IT TOOK FOUR MILLION
YEARS FOR HUMANITY TO
REACH THE 2 BILLION MARK,
ONLY 30 YEARS TO ADD A
THIRD BILLION, AND NOW
WE'RE INCREASING BY
95 MILLION EVERY
SINGLE YEAR.
NO WONDER THEY CALL IT THE HUMAN RACE

ZERO POPULATION GROWTH

HUMANS HAVE RAISED THE
CEILING ON GROWTH MANY
TIMES IN THE PAST· WHEN
HUNTER-GATHERERS RAN
SHORT OF WILD FOODS THEY
TURNED TO FARMING· WHEN
WESTERN EUROPEANS
STARTED TO RUN OUT OF
WOOD IN THE SEVENTEENTH
CENTURY· THEY TURNED TO
COAL· THE PROCESS
CONTINUES TODAY· WHEN
ONE RESOURCE RUNS DOWN·
ITS PRICE CHANGES· AND WE
INCREASE PRODUCTION OR
EXPLORATION· BRING IN
SUBSTITUTES· OR REDUCE USE·
IN OTHER WORDS· WE DO
NOT JUST STAND BY AND
WATCH HELPLESSLY WHILE
THE WORLD COLLAPSES· WE
RESPOND AND ADAPT· WE
CHANGE OUR TECHNOLOGY·
OUR CONSUMPTION
PATTERNS· EVEN THE NUMBER
OF CHILDEN WE HAVE·
IT IS BECAUSE WE CAN ADAPT
SO FAST THAT WE ARE THE
DOMINANT SPECIES
ON EARTH·

PAUL HARRISON

85. ANNIE CICALE Fletcher, NC
Zero Population Growth Banner (one of a series), 1994
Brush, gouache, mylar, wood moldings

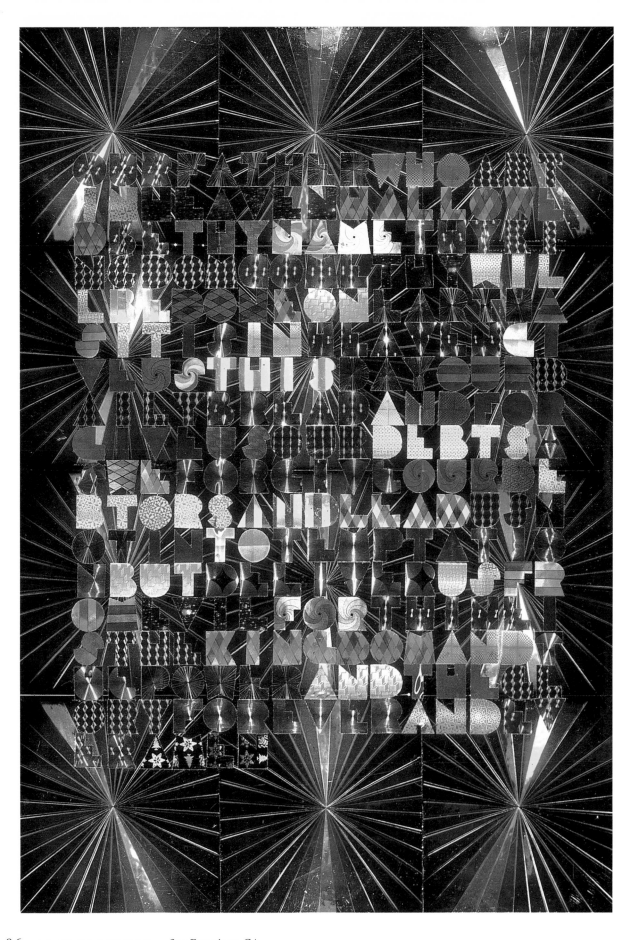

86. ALAN BLACKMAN　San Francisco, CA
Symmetrical Prayer, 1986
Diffraction foil, scissors, design worked out on 1-inch-squared graph paper

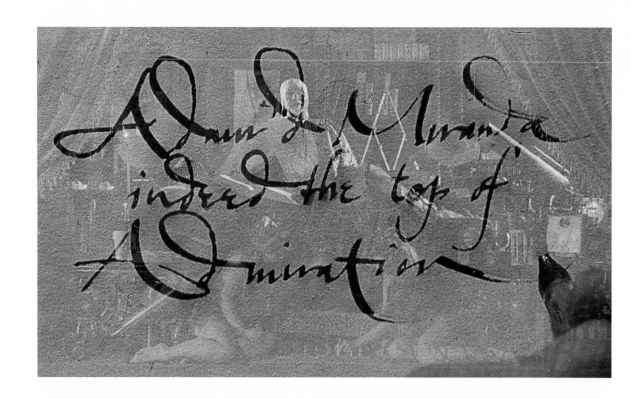

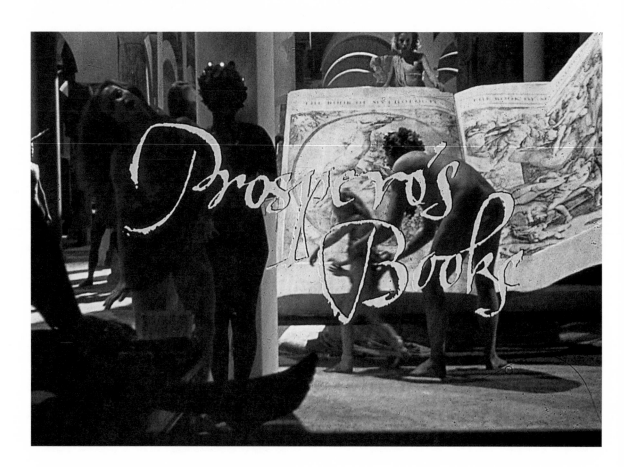

87. BRODY NEUENSCHWANDER Bruges, Belgium
Film title for Prospero's Books, 1990
Quill pen, ink on paper, written live for filming

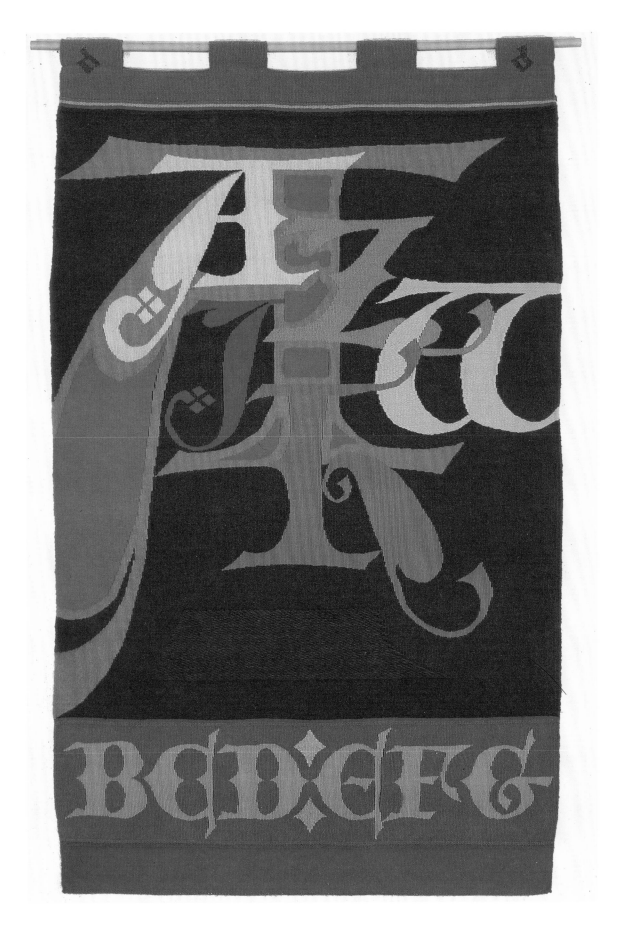

88. DICK BEASLEY (1934–1992) Flagstaff, AZ
"A" Tapestry, 1979
Woven wool weft on cotton warp

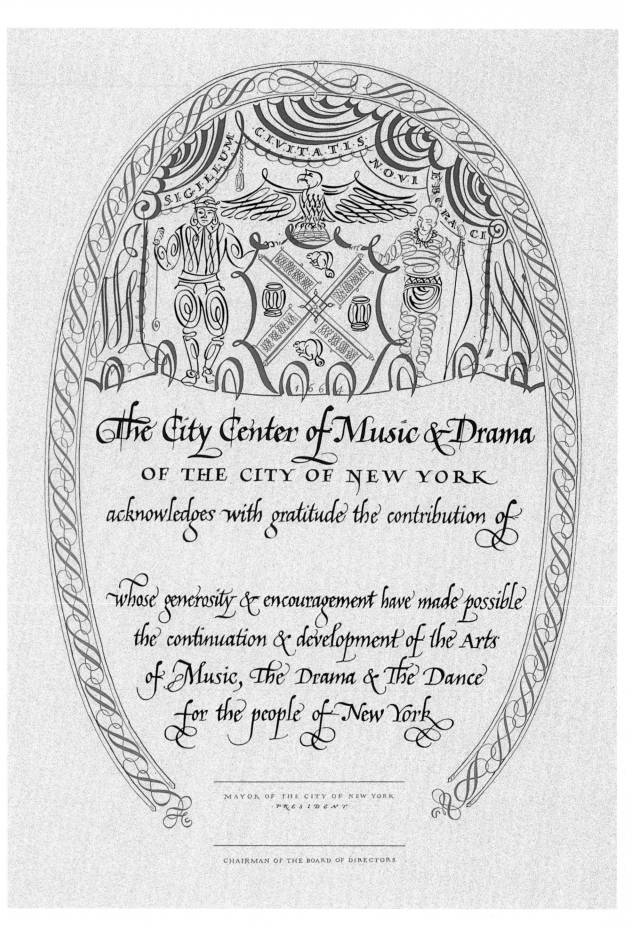

89. ARNOLD BANK (1908–1986) Pittsburgh, PA

The City Center of Music & Drama (contribution acknowledgement), ca. 1950

Silk-screen and letterpress reproduction on Green & Co. handmade paper (original art with flexible pointed nib and broad edge nib, black ink)

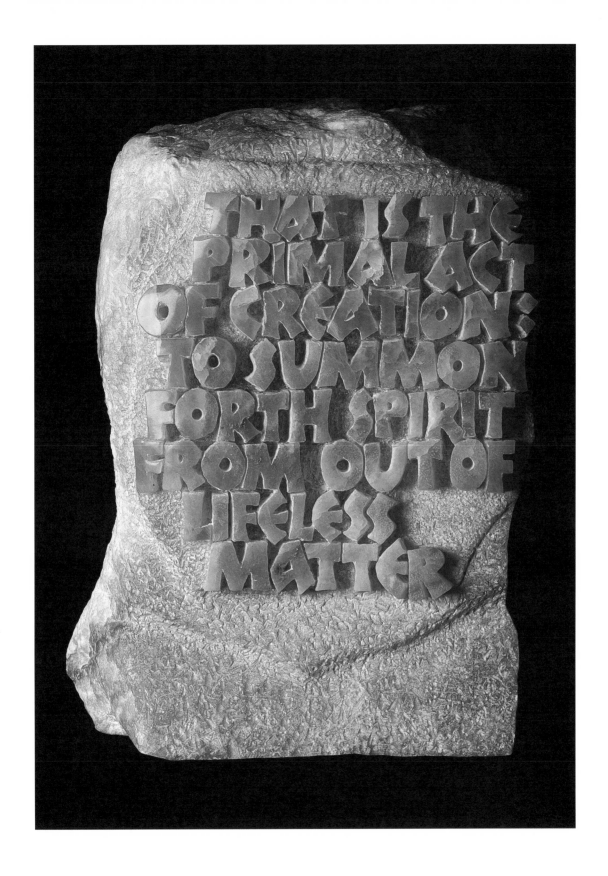

90. REGGIE EZELL Chicago, IL
Spirit from Matter, [n.d.]
Carved Utah alabaster

GALLERY 303

91. EDWARD CATICH (1906–1979) Davenport, IA
 Gallery 303, ca. 1970
 V-cut Roman capitals in slate, painted red, "303" in gold leaf

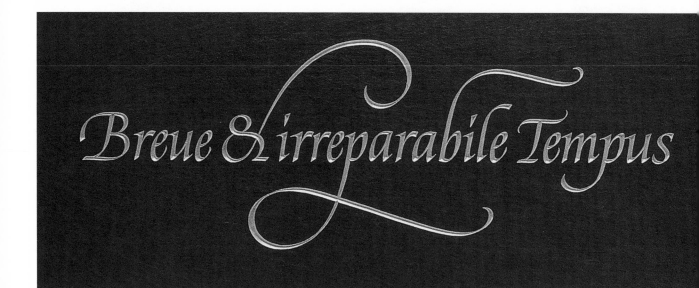

92. NICHOLAS BENSON Newport, RI
 Brief and Irreparable is Time, 1990
 Gilded cleft Buckingham slate

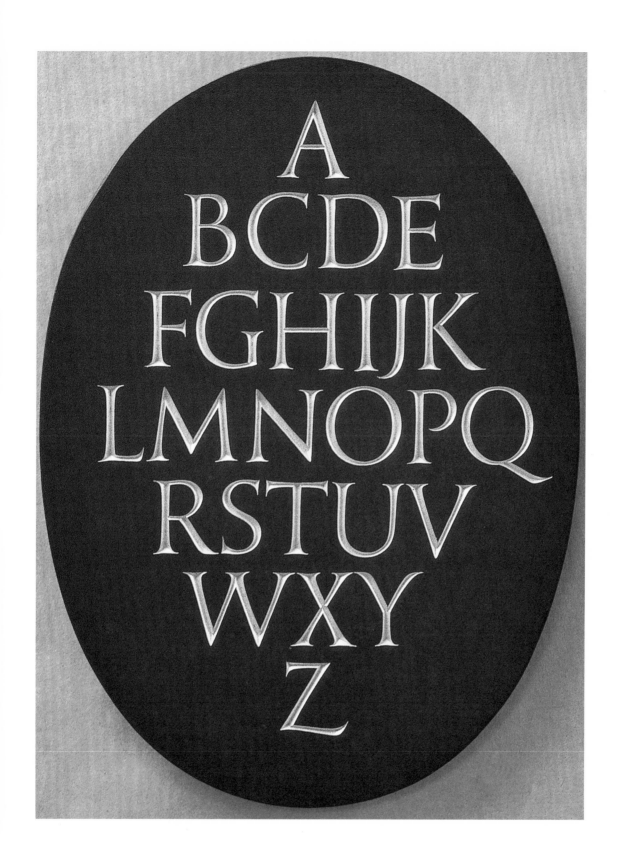

93. JOHN EVERETT BENSON Newport, RI
Alphabet Stone, 1976
Gilded Buckingham slate

94. NANCY RUTH LEAVITT Stillwater, ME
The Book of Rocks, 1999
Gouache on handmade muslin paper, dyed limp vellum binding

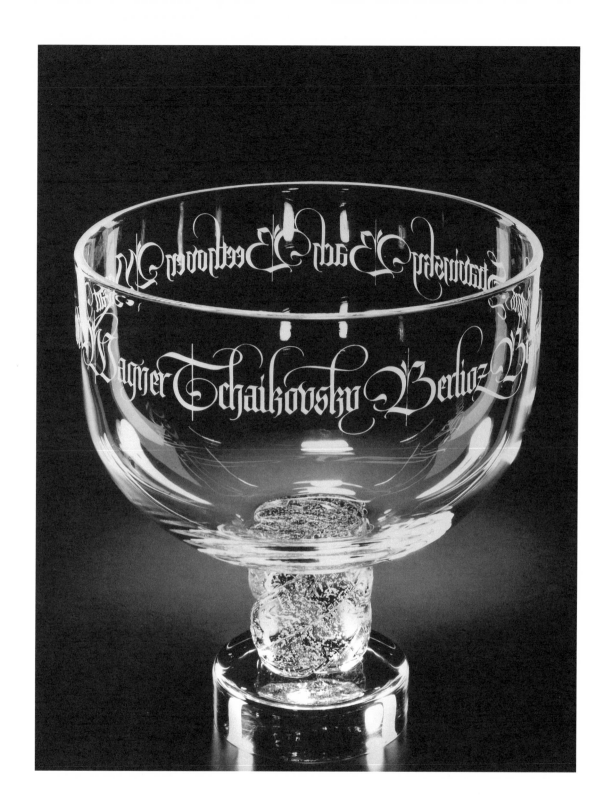

95. EMILY BROWN SHIELDS Long Island City, NY
Composers Bowl for Steuben Glass, 1986
Glass design by David Dowler. Photography by Robert Moore.
Original lettering: Automatic pen, fount India ink, paper, photographic transfer process, positioned lettering sandblasted in 5 different sections

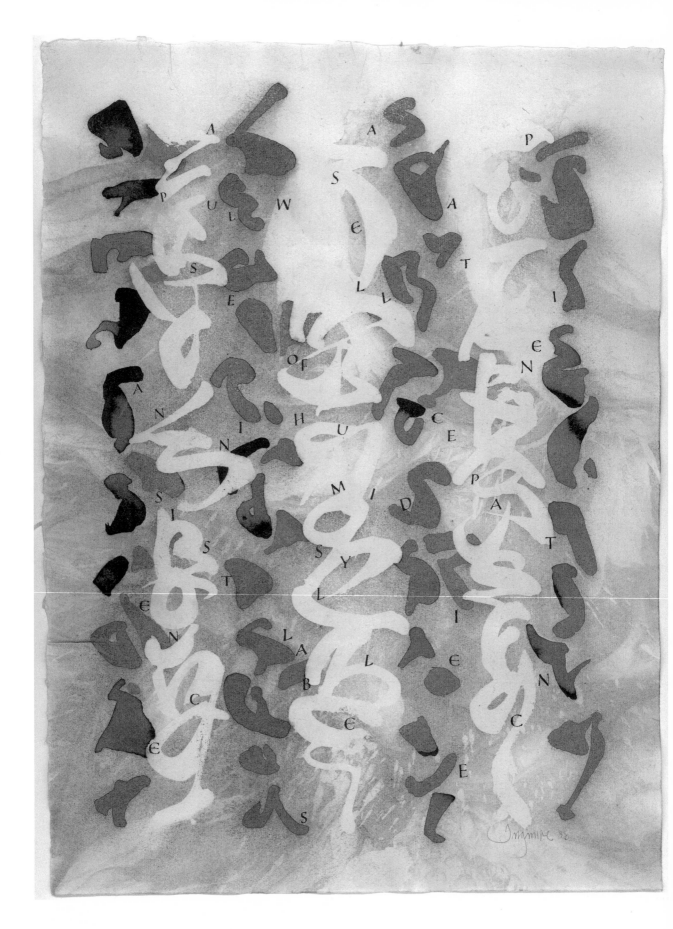

96. THOMAS INGMIRE San Francisco, CA
A Pulse..., 1998
Brush, pen, sumi ink, B-9 handmade paper

What is right and what is wrong, by the law?
My short sword or my long,
A weak arm or a strong, for to draw?

What makes heroic strife, famed afar?
To wet the assassins knife,
Or haunt a parents life, with bloody war?

Then let your schemes alone, in the state,
Adore the rising sun,
And leave a man undone to his fate.

79/125

from a Scottish Jacobite Song w Howard Glasser

97. HOWARD GLASSER Assonet, MA

Jacobite Song, 1972

Print edition (original done with broad-edge nib, paper-cut illustration)

IF IT HAD NOT BEEN FOR THESE THING, I MIGHT HAVE LIVE OUT MY LIFE TALKING AT STREET CORNERS TO SCORNING MEN. I MIGHT HAVE DIE, UNMARKED, UNKNOWN A FAILURE. NOW WE ARE NOT A FAILURE. THIS IS OUR CAREER AND OUR TRIUMPH. NEVER IN OUR FULL LIFE COULD WE HOPE TO DO SUCH WORK FOR TOLERANCE, FOR JOOSTICE, FOR MAN'S ONDERSTANDING OF MAN AS NOW WE DO BY ACCIDENT. OUR WORDS-OUR LIVES-OUR PAINS NOTHING! THE TAKING OF OUR LIVES-LIVES OF A GOOD SHOEMAKER AND A POOR FISH PEDDLER-ALL! THAT LAST MOMENT BELONGS TO US- THAT AGONY IS OUR TRIUMPH.

98. BEN SHAHN New York, NY
Immortal Words, 1958
Silkscreen on paper

99. CHRISTOPHER CALDERHEAD Cambridge, England
Mene Mene Tekel Upharsin: Daniel 5, 1990
Offset-printed in two colors from original calligraphy

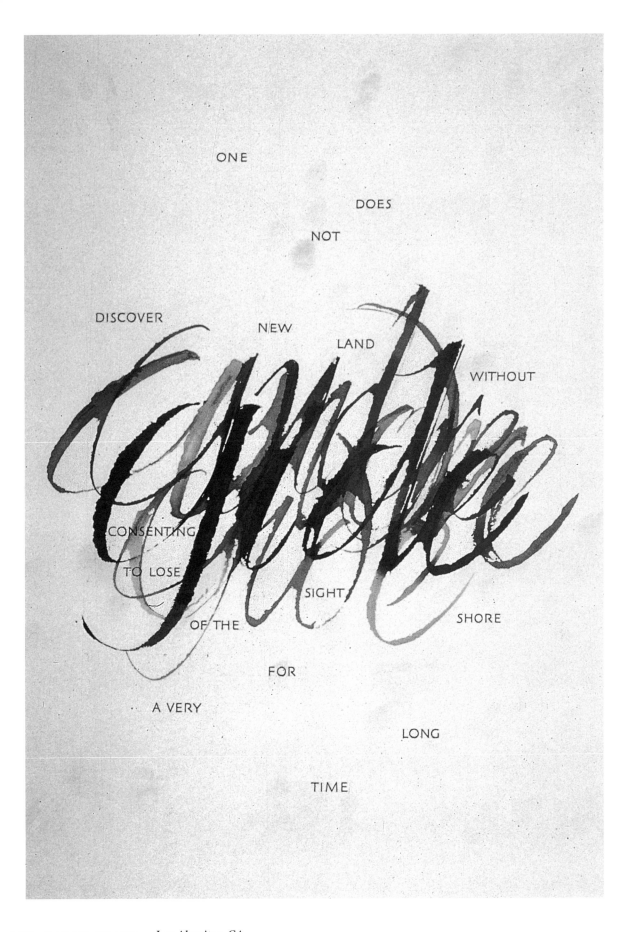

ONE

DOES

NOT

DISCOVER NEW LAND WITHOUT

CONSENTING

TO LOSE SIGHT SHORE

OF THE

FOR

A VERY

LONG

TIME

100. LARRY BRADY Los Alamitos, CA
André Gide Quote, 1997
Ruling pen, pointed pen, Parker ink, 140# Arches cold-press watercolor paper

Among the many sects
that arose about AD 1000, the alchemists
played an important part. They exalted
the mysteries of matter & set them alongside of
the heavenly spirit of Christianity.
There was a wholeness of
man encompassing
mind & body, and they
invented a thousand names
and symbols for it.
One of their central
symbols was the squared
circle – symbol of
wholeness & of the union of
opposites. Today with few exceptions
the traditional mode of representation
has undergone a characteristic
transformation that corresponds to the
dilemma of modern man's existence.
The circle is no longer the
meaningful figure that
embraces a world. ANIELA JAFFÉ

101. JERRY KELLY New York, NY
Aniela Jaffé Quote, 1986
Mitchell pens, calligraphy and brush for diagram on mould-made paper

THE FABULIST

NUMBER 3 AUTUMN

1921

Myself, I hope to live in a land that I have made out of potsherds and broken bits. It is not a well-articulated country, and it is not different from a many that other people have made. There are old things in it, but it is not old. I manage to have arched masonry dug out of Rome, and Greek fragments of marble, but the colonists from Greece have forgotten their fatherland, and pasture their cattle under the columns. There are glints from the East in the land if there are really no Easterners there. I use words to furnish this part of the country— Samarkand and Ispahan. They do as much as real colonists would, and much more musically. I do not need real things in this part, I choose rather invocations of memories or imaginings. All the claptrap of Oriental imagery serves me very well,–dust and sun and faded bright colors. There are no cities, and there are only the more picturesque sorts of merchants. How the inhabitants live I am not too much inclined to ask being overclose to the problem myself in this part of the world. But they are mostly countrymen and work in the soil

You will see that the country is hopelessly romantic, hopelessly to you, I mean. For a time back I was ashamed of its nearness to ruined Rome and hid its existence. Now I have grown careless about your opinions & am inclined to live in whatever land I please.

D.

1

102. W.A.DWIGGINS (1880−1956) Hingham, MA

The Fabulist, 1921

Booklet printed by letterpress from line plates of Dwiggins's original calligraphy

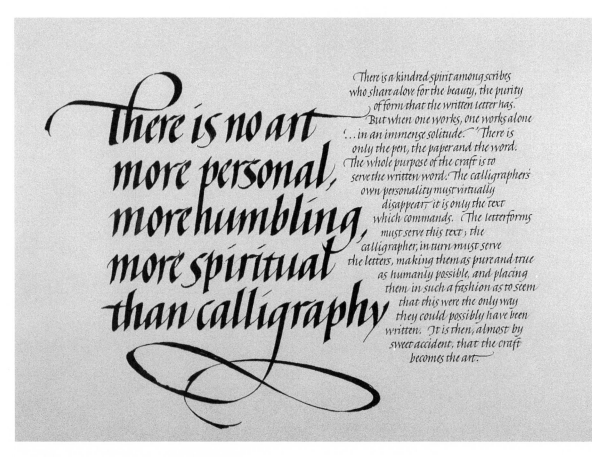

103. PATRICIA BUTTICE Hempstead, NY
No Art More Personal (Text by the artist), 1985
Coit and Mitchell pens, red and black Winsor & Newton gouache, Invicta parchment paper

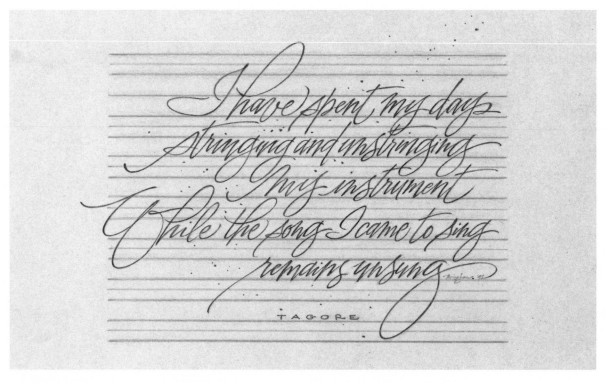

104. SHERRY BRINGHAM El Cerrito, CA
Song Unsung, 1991
Steel nibs, PH Martins dyes, Arches paper, colored pencils

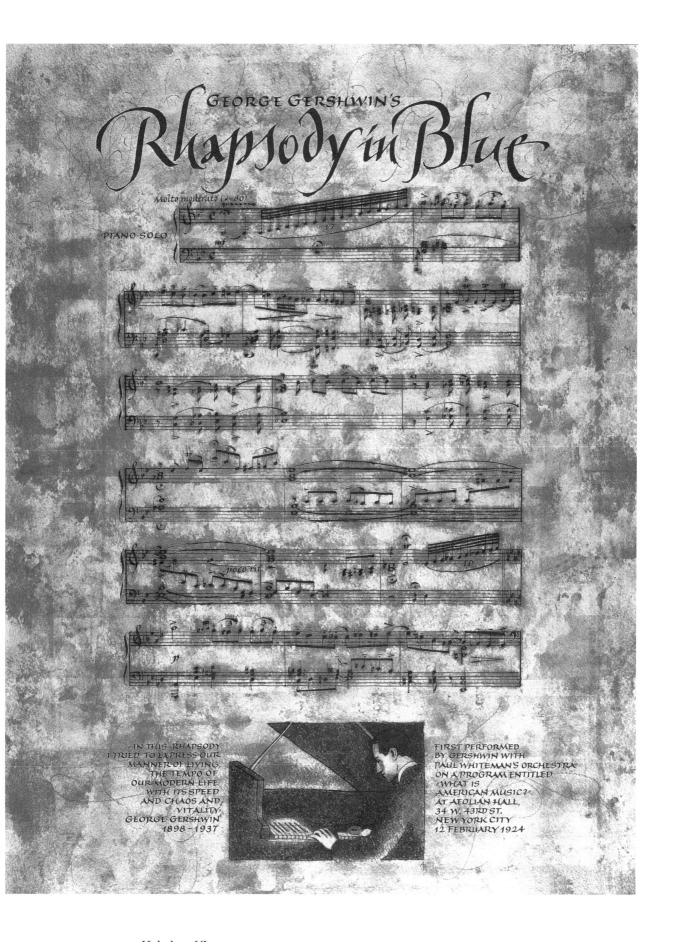

105. ANNA PINTO Hoboken, NJ

Gershwin: Rhapsody in Blue, 1996

Mitchell 5-line music nib, Speedball nibs, stencil brush, gouache, watercolor, color pencil, sponged watercolor background, Saunders watercolor paper

106. ANITA KARL Brooklyn, NY
The New York Times Magazine cover, Nov. 1, 1998, 1998 [DETAIL]
Art director: Janet Froelich. Designer: Catherine Gilmore-Barnes. Copywriter: Gerald Marzorati
Square cut Mitchell pen, ink, heavy vellum paper

107. GEORGINA ARTIGAS Miami, FL
To a Little Boy's Father, 1994 [DETAIL]
170 Gillott nib, black Japanese stick ink, Canson Mi Tients paper, Holbein gold watercolor, copper black, white
& brown, pure gold powder, and gold leaf

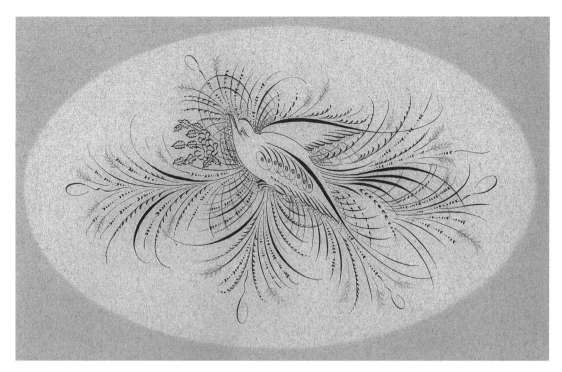

108. MICHAEL SULL Mission, KS

Ornamental Bird, 1995

Esterbrook nib, oblique pen holder, sumi vermilion/eternal ink mix, Nideggen paper, Schmincke gold gouache

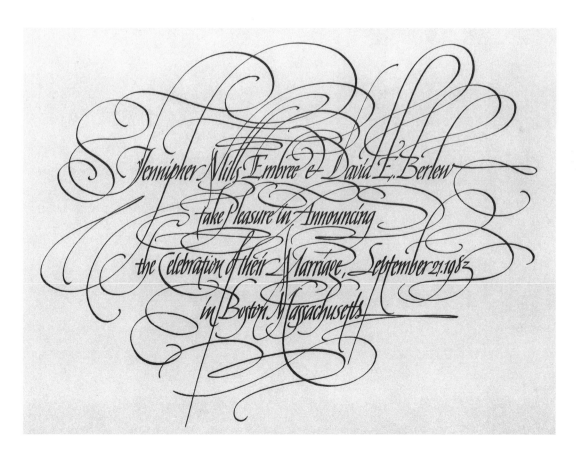

109. RAPHAEL BOGUSLAV Newport, RI

Wedding Announcement, 1983

Original written with calligraphic fountain pen

110. PATRICIA WEISBERG New York, NY
Calligraphic monograms for glass at Steuben, Various years
Pen, brush, ink, paper

Classical Composers & Conductors

Opera Singers

Rock & Roll / Rhythm & Blues

111. JULIAN WATERS Gaithersburg, MD
Lettering Work / U.S. Postal Service, 1987–98
Printed headings for stamp blocks (original: ruling pens, Speedball and Mitchell nibs, black ink, white retouching gouache, small brush, watercolor paper, bond paper)

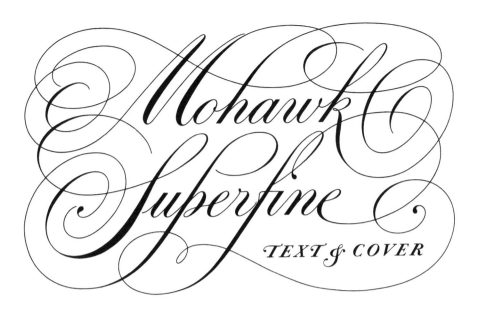

Mohawk Superfine
TEXT & COVER

112. FREEMAN CRAW Millburn, NJ
Mohawk Superfine, 1990
Offset reproduction of hand lettering for paper promotional book

If a man be gracious and courteous to strangers, it shows he is
a citizen of the world, and that his heart is no island
cut off from other lands, but a continent that joins to them.
FRANCIS BACON · 1561–1626

MARTIN G. PICILLO
P·R·E·S·I·D·E·N·T / 1·9·9·7 – 1·9·9·8
Essex County Bar Association

THE officers and trustees honor you tonight, May 19, 1998, and
always, for your thoughtful and gracious leadership of our
Association. We are all enhanced as a profession because of your
integrity, your common sense approach to everyday issues facing
the legal profession and your dedication to all that is good. You made
a significant difference for all of us and for that we thank you.

PAUL G. NITTOLY · PRESIDENT · 1998–1999

113. MARCY ROBINSON Nutley, NJ
Certificate honoring Martin G. Picillo, 1998
Speedball nib, Rexel nib, sumi ink, Arches text wove paper

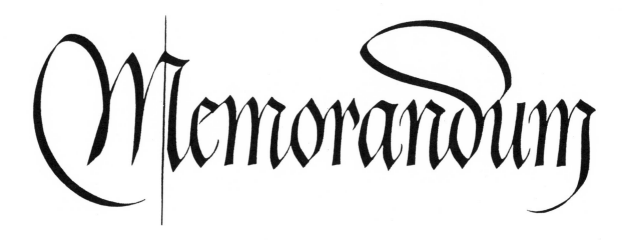

Memorandum

SPECIMENS

114. FREEMAN CRAW Millburn, NJ

Memorandum, ca. 1950s
Lettering for reproduction

Specimens: Title-page spread, ca. 1950s
Letterpress-printed for paper sample book

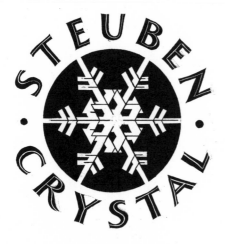

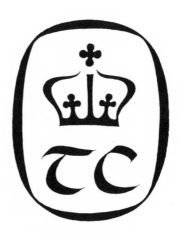

115. PHILIP GRUSHKIN
(1921–1998)
Englewood, NJ

Steuben Crystal Logo,
[n.d.]
Black and retouch white,
bristol board

TC Columbia / Teachers'
College Logo
Black and retouch white
on bristol

116. ISKRA JOHNSON Seattle, WA
Lettering on Lord & Taylor Christmas Ad
Edged pens, ink, watercolor

I went to the Garden of Love,
And saw what I never had seen:
A Chapel was built in the midst,
Where I used to play on the green.

And the gates of this Chapel were shut,
And Thou shalt not writ over the door;
So I turn'd to the Garden of Love
That so many sweet flowers bore;

And I saw it was filled with graves,
And tomb-stones where flowers should be:
And Priests in black gowns were walking their rounds,
And binding with briars my joys & desires.

THE LITTLE BOY LOST

Father! father! where are you going?
O do not walk so fast.
Speak, father, speak to your little boy,
Or else I shall be lost.

The night was dark, no father was there;
The child was wet with dew;
The mire was deep & the child did weep,
And away the vapour flew.

117. REYNARD BIEMILLER (1910–1995) Hampton Bays, NY
Blake: Selections from Songs of Innocence and Experience
Book printed in two colors from original calligraphy

Youth is not entirely a time of life – it is a state of mind. It is not wholly a matter of ripe cheeks, red lips or supple knees. It is a temper of the will, a quality of the imagination, a vigor of the emotions, a freshness of the deep springs of life. It means a temperamental predominance of courage over timidity, of an appetite for adventure over love of ease.

Nobody grows old by merely living a number of years. People grow old only by deserting their ideals. Years may wrinkle the skin, but to give up interest wrinkles the soul. Worry, doubt, self-distrust, fear and despair – these are the long, long years that bow the head and turn the growing spirit back to dust.

Whatever your years, there is in every being's heart the love of wonder, the undaunted challenge of events, the unfailing child-like appetite for what's next, and the joy and the game of life.

You are as young as your faith, as old as your doubt; as young as your self-confidence; as old as your fear; as young as your hope, as old as your despair.

In the central place of every heart there is a recording chamber; so long as it receives messages of beauty, hope, cheer and courage, so long are you young.

When the wires are all down and your heart is covered with the snows of pessimism and the ice of cynicism, then, and then only are you grown old.

GEN. DOUGLAS MACARTHUR

Quoted from the poem "Youth" by Samuel Ullman

118. PHILIP GRUSHKIN (1921–1998) Englewood, NJ
Youth is Not Entirely a Time of Life, [n.d.]
Offset-printed from original broad pen calligraphy

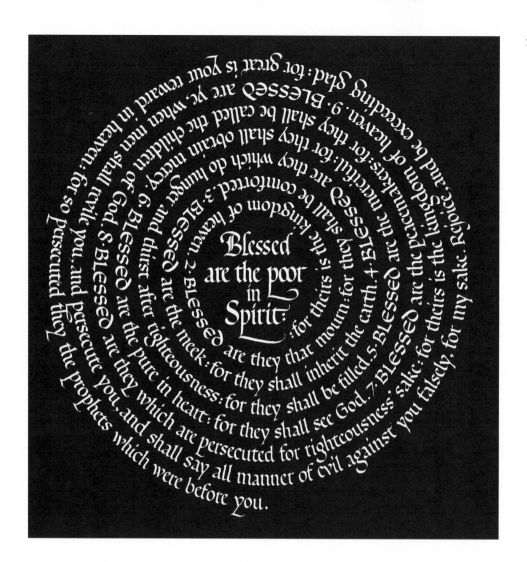

119. BYRON
MACDONALD
San Francisco, CA
Christmas Card, 19[
road-edge pen on p.

120. HOLLIS
HOLLAND
New York, NY
*Greetings to the
Farrier,* [n.d.]
Original broad-
edge pen letter-
ing. Headline
lettering by
Oscar Ogg.

THE LUCKY HORSESHOE

No wonder skies upon you frown;
You've nailed the horseshoe upside down!
Just turn it 'round, and then you'll see
How you and Fortune will agree.

JAMES THOMAS FIELDS [1816-1881]

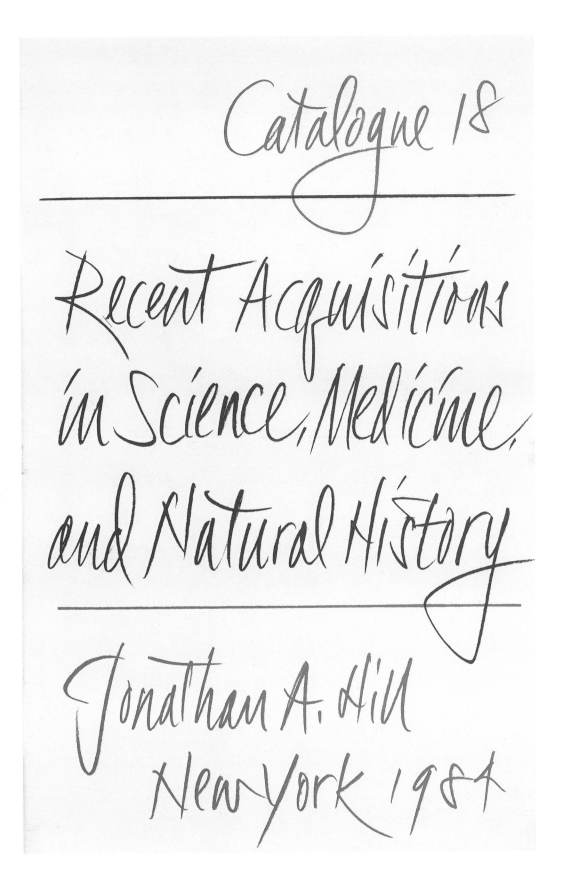

Catalogue 18

Recent Acquisitions
in Science, Medicine,
and Natural History

Jonathan A. Hill
New York 1984

121. PHILIP GRUSHKIN (1921–1998) Englewood, NJ
Jonathan A. Hill catalogue cover #18 (1984)
Offset-printed in two colors from original calligraphy

122. OSWALD COOPER (1879–1940) Chicago, IL
Fifty Books of 1923 Poster, ca. 1923
Printed in two colors

BIOGRAPHIES OF THE ARTISTS

92 NICHOLAS BENSON Son of John E. Benson, and grandson of lettering artist and stone carver John Howard Benson; began apprenticeship at the John Stevens Shop in 1979; studied design at SUNY, Purchase, NY, and calligraphy and letterform design at the Kunst Gewerbeschule, Basel; currently owner and operator of the John Stevens Shop, Newport, RI.

117 REYNARD BIEMILLER (1910, Baltimore, MD–1995, Hampton Bays, NY) Designer, letterer, calligrapher, and typographer; studied typography and printing under Joseph Blumenthal, later became production manager of the Spiral Press; taught lettering at The Cooper Union and typography at the AIGA Workshops; designed books and jackets for Knopf, Morrow, Random House and Scribner's; numerous exhibitions; noted for drawings and watercolors made in Africa and Hawaii; many hand-written books including an Archway Press edition of *Selections from the Songs of Innocence and Experience*.

86 ALAN BLACKMAN Studied lettering at California College of Arts & Crafts, Oakland, in the late 1950s; designed *Galahad* typeface issued by Adobe Systems; teaches in the US and Europe; best known for his unique thirty-year personal collection of calligraphically designed first-day cover envelopes; represented in the Harrison Collection, San Francisco Public Library, and the Victoria & Albert Museum, London.

22, 23, 109 RAPHAEL BOGUSLAV A calligrapher for fifty-five years; studied with Paul Standard and George Salter at The Cooper Union; worked for Lippincott & Margulies, New York, designing logos and package designs; teaches calligraphy at Rhode Island School of Design and conducts workshops in the US; work published and exhibited extensively; currently living in Newport, RI.

44 ROBERT BOYAJIAN Graduate of the School of Practical Art, Boston, 1952; received Honorary BFA in 1994 from the Art Institute of Boston; lettering artist and art director at J. Walter Thompson Co., New York, 1953–72; free-lance lettering artist, graphic designer, and calligrapher, 1974–96; taught calligraphy workshops in the US and Canada; currently enjoying retirement in Newport, RI.

100 LARRY BRADY Professor of Design at Cerritos College, CA, for twenty-seven years, and Dean of Fine Arts & Communications for the past three; maintains a design studio specializing in lettering, packaging, corporate identity, and alphabet design; continues to study calligraphy.

5 MARSHA BRADY Head of two-year program in calligraphic studies, Cerritos College, CA; teaches and lectures throughout the US; exhibits internationally; published in *Letter Arts Review*, *The Creative Stroke*, and *Modern Scribes & Lettering Artists II*; works jointly and collaborates with her husband Larry Brady.

SHERRY BRINGHAM Commercial lettering artist, lives and works in El Cerrito, CA; work appears on supermarket packaging, in advertising campaigns, and on television commercials.

PATRICIA BUTTICE Founding member of Island Scribes, NY; faculty member, Nassau Community College; teaches workshops in the US, Puerto Rico, Canada, and at international conferences; adjunct faculty member, Adelphi University, NY; work exhibited in the US and internationally; published in *Calligraphers Engagement Calendars*, *Contemporary Calligraphy*, *Modern Scribes & Lettering Artists*, *Florilège*, and *The Speedball Textbook*; reader at the Morgan Library researching historic alphabets; author of articles on calligraphy and related subjects.

CHRISTOPHER CALDERHEAD BA in Art History, Princeton University; trained by Ann Camp at Roehampton Institute, London; elected Fellow of the Society of Scribes and Illuminators, UK, 1988; taught calligraphy and lettering throughout the US; entered training for Christian ministry, 1995; currently works as an assistant curate in a parish in Cambridge, England; continues to teach calligraphy and to work on lettering in his studio.

REV. EDWARD M. CATICH (1906, Stevensville, MT–1979, Davenport, IA) Sign writer, musician, calligrapher, stone-carver, and author; MA in Fine Arts, University of Iowa; show-card writer in Chicago; played jazz in local nightspots; studied for the priesthood and was ordained in Rome in 1938, where he started his famous studies of the Trajan Column; spent four years (1935–39) of intense research in paleography and epigraphy formulating the linkages between Roman inscriptions and Chicago signwriting; W. A. Dwiggins convinced him to publish these studies—thus, *Letters Redrawn from the Trajan Inscription* (1961) and *The Origin of the Serif* (1968) are now familiar books to lettering artists around the world.

WARREN CHAPPELL (1904, Richmond, VA–1991, Charlottesville, VA) Graduate of the University of Richmond, VA; studied and taught printmaking and typographic design at the Art Students League of New York; learned lettering and type-cutting with the German master Rudolf Koch at the Offenbacher Werkstatt; designed typefaces *Lydian* and *Trajanus*; taught drawing at the Colorado Springs Fine Art Center; book designer, chiefly for Knopf and Random House, and illustrator of many children's books; author of *Anatomy of Lettering* (1935) and *A Short History of the Printed Word* (1970).

KAREN CHARATAN Sign-painter and calligraphic lettering artist; has been making signs for shopping malls, stores, hospitals, and businesses for over twenty years; teaches internationally; author of the how-to marker book *ABCZIG Calligraphy*; art director and editor of NEWSos while on the Board of Governors of the New York Society of Scribes; currently focusing on greeting card design, commercial lettering, wall murals, and exterior electrical signage.

85 ANNIE CICALE BFA in Printmaking; MFA in Graphic Design; has taught art from elementary school to university levels; on faculty of fifteen international calligraphy conferences; teaches workshops throughout North America; published in *Calligraphers Engagement Calendars*, *Modern Scribes and Lettering Artists II*, *The Speedball Textbook*, and *Lettering Design*; numerous one-person shows, including "The Face of Humanity" installation; divides her time between teaching, graphic design work, and painting.

122 OSWALD ("OZ") COOPER (1879, Mount Gilead, OH–1940, Chicago, IL) Letterer, type designer, and calligrapher; raised in Coffeyville, Kansas; at twenty went to Chicago, there beginning his long friendship with Frederic Goudy and W. A. Dwiggins at the Frank S. Bertsch School of Illustration; co-founded Bertsch & Cooper in 1904 as a lettering and layout man; went on to become the most influential lettering artist of his day in the Midwest; designed many typefaces including the tremendously successful *Cooper Black* (1921), which he described as "for far-sighted printers with near-sighted customers."

38 TOM COSTELLO Lettering artist in the Boston area, specializing in awards, citations, honorary degrees, titling, and logotype design for the past two decades; regards Edward A. Karr, Sheila Waters, and Hermann Zapf as his inspiration and information sources.

112, 114 FREEMAN (JERRY) CRAW Graphic designer and consultant; designer of typefaces for the American Type Founders Co., as well as for photolettering and digital type systems; recipient of awards from the American Institute of Graphic Arts, the Art Directors Clubs of New York and New Jersey, the Type Directors Club, and the Gutenberg Museum (Germany); work included in graphic arts collections of the Museum of Modern Art and the Cooper-Hewitt Museum; one-person exhibitions at Rochester Institute of Technology, Cooper Union, the Royal College of Art (London), and elsewhere.; designs published in the US and internationally.

65 NANCY CULMONE Has taught calligraphy at colleges, museum schools, and workshops since 1976; published and exhibited in private and public collections including Wellesley College and Harvard University; lives and works in a remote area of New Mexico.

55, 76 RICK CUSICK Calligrapher and designer; studied at San Joaquin Delta College, CA, and at the Art Center College of Design in Los Angeles; began work at Hallmark Cards in 1971 as a lettering artist, type, and book designer; accumulated significant calligraphic education from correspondence with Ray Da Boll, Lloyd Reynolds, and Warren Chappell, resulting in an association with TBW Books as a design and editorial consultant, and leading to the publication of *With Respect to RFD*, *Straight Impressions*, and *The Proverbial Bestiary*; designed *Nyx* for Adobe Systems; art director of *Letter Arts Review* since 1993.

RAYMOND F. DABOLL (1892, Clyde, NY–1982, Elizabeth, IL) Calligrapher, 1
designer, and author; art studies at Rochester Athenaeum & Mechanics Institute,
Rochester, NY, and Art Institute of Chicago; most valuable experience: "handy man to
Oz Cooper, 1919–1922." Began intensive calligraphy study in 1937 under Ernst Detter-
er at the Newberry Library; designed *Calligraphy's Flowering, Decay & Restauration* by
Paul Standard (1947) and *The Book of Oz Cooper* (1949); author, designer, and calligra-
pher of the broadside *Disciplined Freedom*, giving the principles of Arrighi's broad-pen
technique (1948); author, calligrapher, and illustrator of *Recollections of the Lyceum and
Chautauqua Circuits*, a lively volume of Americana and reminiscences of his wife's ex-
periences as a child singer on the Circuit, embellished with witty marginal sketches
and knowledgeable comments on scribal art and his experience with it.

ISMAR DAVID (1910, Breslau, Germany–1996, New York) Attended the Berlin 6
Municipal School for Arts and Crafts; in 1932 opened a studio in Jerusalem for graph-
ic and interior design; created a new family of typefaces called *David Hebrew* in 1952;
in 1953 established a studio in New York specializing in calligraphy, illustration, and
book design; taught calligraphy at Pratt Institute and The Cooper Union; a skilled ar-
chitect, he designed the Palestine Pavilion at the New York World's Fair and many
distinguished cemetery monuments.

GEORGIA DEAVER Calligrapher and designer based in San Francisco; exhib- 77
ited and won numerous awards internationally; elected Fellow of the Society of
Scribes and Illuminators, UK; worked in Austria with Neugebauer Verlag; teaches,
lectures, and juries extensively throughout the US; published in *Typography 4, 5, & 6*,
Annuals of the Type Directors Club, *Modern Scribes & Lettering Artist II*, and the *63rd
Art Directors Annual*.

CLAUDE DIETERICH Raised in Avignon, France; studied graphic design and 64
fine arts in Grenoble; worked in Paris specializing in magazine design; emigrated to
Peru in 1961; opened a design studio in Lima; Dean, Graphic Design Dept., Catholic
University, Lima, for seven years; studied calligraphy with Hermann Zapf; taught
typography and letterforms, Academy of Art, San Francisco, from 1992–98; currently
free-lancing and teaching in the US and internationally.

WARD DUNHAM Discovered the chisel-edged pen in 1964 while in military 17, 24
service in Vietnam; attended Donald Jackson's three-week seminar at the Calligra-
phy Workshop, New York, 1974; specializes in Gothic lettering; published in *Modern
Scribes and Lettering Artists* and *Lettering Arts*; indebted to Huynh Thi Xuan, Georgian-
na Greenwood, Byron J. Macdonald, Louis Strick, and Linnea Lundquist; a founding
member of the Society of Scribes.

WILLIAM ADDISON DWIGGINS (1880, Martinsville, OH–1956, Hingham, 102
MA) Type designer, book designer, calligrapher, puppeteer, costume designer, and
playwright; thirty-seven of the books he designed were among those selected for the

Fifty Books of the Year series sponsored by the American Institute of Graphic Arts; AIGA Gold Medal in 1929; a pioneer in using a broad-edged pen to design modern typefaces; his studio and marionettes can be seen in the Dwiggins Room at the Boston Public Library.

21 FRITZ EBERHARDT (1917, Germany–1997, Schwenksville, PA) Bookbinder, designer, and calligrapher; studied fine bookbinding at the Leipzig Academy for Graphic Arts (where exercises in lettering were a *mandatory* part of instruction); en route to becoming a master bookbinder in the 1930s, he studied calligraphy under the brilliant Rudo Spemann; after WWII escaped from the Soviet zone of occupation to the American zone and eventually to the Werkkunstschule in Offenbach where he continued his calligraphy studies under the skilled teaching of Hermann Zapf; emigrated to the US in the early 1950s; began work in Philadelphia in the bookbinding restoration of an important collection of Frankliniana; developed a successful freelance business with his wife, also a master binder.

81 JEAN EVANS Type designer, calligrapher, and maker of artist's books; works appear in annuals, publications, public, and private collections around the world; concentration in recent years on type design including *Elli*, commissioned by the Houghton Library, Harvard University, and *Dizzy*, based on the handwriting of trumpeter Dizzy Gillespie; latest releases are *Rats* and *Hatmaker*.

90 REGGIE EZELL Has spent the last fourteen years traveling forty-eight weekends a year teaching his year-long course in calligraphy throughout the US and Canada; his most recent works are three-dimensional, combining stained glass, terra cotta sculpture, acrylic resins, and light.

47 ROSE FOLSOM Calligrapher since 1973; studied with Sheila Waters, Ieuan Rees, and Hermann Zapf; exhibited large abstract pieces in the late 1980s; currently produces manuscript books, included in collections at Harvard University, RIT, and elsewhere; author of *The Calligraphers' Dictionary*; exhibits internationally; lives in Silver Spring, MD.

[page 14] PAUL FREEMAN (1929, Brooklyn, NY–1980, New York, NY) Degree from New York City College; teacher, author, sculptor, and painter, frequently depicting jazz musicians and religious subjects; illustrated *Songs of Man*, an anthology of international folk songs by Norman Luboff; designed textiles, book jackets, and ceramics; attended Donald Jackson's calligraphy workshop in 1974; learned the tools of the scribe, then developed his own dynamic style of broad-pen writing and drawing; founding chairman of the New York Society of Scribes.

28 DAVID GATTI BFA Cornell University, 1953; following a long career in advertising, took up design and lettering for book jackets in 1978; has designed covers for over 4,000 books; lives in Huntington, NY.

ship studying punch-cutting and engraving with Sem Hartz in Haarlem and stone cutting with Will Carter in Cambridge; completed a year of stone-cutting at the John Stevens Shop in Newport before joining The Stinehour Press in 1973; many published writings, including *An Italic Copybook: The Cataneo Manuscript* (1981).

50 JAMES HAYES (1907, Saginaw, MI–1993, Woodland Park, CO) Art training at the Art Institute of Chicago studying under Ernst Detterer; free-lanced and also worked in the Marshall Field & Co. Interior Display Department, 1933–40; spent twenty-one months overseas in military service during WWI; calligraphy clients included the Newberry Library, the Lakeside Press, and the University of Chicago; directorship of Newberry Library Calligraphy Study Group in 1947; designed distinguished bookplates.

18 LOTHAR HOFFMANN Born in Germany, studied in Berlin, Munich, and Essen before emigrating to the US; worked for major art studios as a graphic designer for twenty years; currently concentrates on publishing fine lettering, calligraphy, and typography, utilizing both electronic and print media.

120 HOLLIS HOLLAND (1908, Memphis, TN) Studio in New York; from 1926 to 1936 he traveled across the country, designing theatrical posters for various motion picture companies; art director for several advertising agencies, notably J. Walter Thompson; specialized in lettering and typographic design for publishers; taught calligraphy and letter design at Columbia University.

79 LORENZO HOMAR Born in San Juan, Puerto Rico; emigrated to New York in 1928; studied at Pratt Institute, New York; served in the US Army, 1941–45; studied at the Brooklyn Museum Art School with Rufino Tamayo, Arthur Osner, and Gabor Peterdi; participated in print biennials in the US, South America, Europe, and Japan; lives in San Juan, PR, and has operated his own design and printing studio for the past several decades.

96 THOMAS INGMIRE BSLA, Ohio State University; MLA, University of California; has taught calligraphy since 1978; conducts workshops in the US and internationally; elected Fellow of the Society of Scribes and Illuminators, UK, 1977; work widely exhibited in the US and included in the Harrison Collection, San Francisco Public Library, the Newberry Library, Chicago, the Victoria & Albert Museum, London, and the Sackner Archive of Concrete and Visual Poetry; published in *Letter Arts Review, Calligraphy Masterclass, Calligraphy, Lettering Arts, Painting for Calligraphers*, and *Words of Risk: the Art of Thomas Ingmire*.

3, 4, 46 DONALD JACKSON Calligrapher, teacher, and author; post-graduate studies with Irene Wellington at Central School of Art, London; lectureship at Camberwell College of Art at age twenty; scribe to Her Majesty Queen Elizabeth's Crown Office of the House of Lords since 1964; in 1969 borrowed the fare and came to New York,

where his life was changed as he began a series of lectures, workshops, and classes throughout the US; featured instructor at the first international calligraphy conference in 1981; author of *The Story of Writing* (1981); founding and now honorary member of the Society of Scribes; presently working on a six-year project to produce the first handwritten and illuminated Bible to be commissioned in the last 500 years.

ISKRA JOHNSON Lettering artist and illustrator with a degree in painting from the University of Washington; published in *Trademarks & Logotypes of the World II*, *Lettering Arts*, *The Creative Stroke*, *U&lc*, *Letter Arts Review*, *Annuals* of the Type Directors' Club, and *Print*; works exclusively for reproduction, designing typefaces and product identities. *116*

EDWARD JOHNSTON (1872, Uruguay, S.A.–1944, Ditchling, England) Calligrapher, author, and highly influential teacher; beginning in 1899, using square-cut quills and reeds, he popularized the art of manuscript writing through his teaching at the Central School of Arts & Crafts, Camberwell College of Art, and the Royal College of Art; his pioneering work in the study of the structure and technique of letterforms was the primary influence behind the modern revival of interest in fine writing and lettering; designed the sans-serif alphabet used by the London Underground Railway in 1916; his *Writing & Illuminating & Lettering* (1906) is still in print and has influenced many generations of scribes. *2*

TED SIMCHA KADIN BFA, Brooklyn College; attended NYU Institute of Fine Arts masters program; on faculty of the Calligraphy Workshop at The New School, New York; currently a calligrapher/lettering artist and designer specializing in Hebrew and copperplate calligraphy and illuminated Ketubot; designer of three typefaces. *83*

ANITA KARL Graduate of The Cooper Union, New York; principal designer/co-owner of Compass Projections Design Studio in Brooklyn, NY; works for book and magazine publishers as a calligrapher/hand-letterer, illustrator, and book and map designer; award-winning lettering for *The New York Times* and *Rolling Stone*. *106*

EDWARD KARR (1909, New Britain, CT–1997, Newton, MA) Began career as a showcard lettering artist in New Britain, CT; maintained a lettering studio in Boston from 1945 to the mid 1980s specializing in calligraphy and illumination; an enthusiastic teacher at the Boston Museum of Fine Arts School for twenty-five years; president of the Society of Printers. *40*

MIKE KECSEG Worked as an engrosser, owns and operates Pen Graphics Studios, Inc.; specializes in writing and teaching pointed pen scripts; exhibits widely; work included in the permanent collection of the Newberry Library, Chicago. *60, 80*

7, 101 JERRY KELLY Calligrapher, designer, and printer; studied with Denis Lund, Don Kunz, and Hermann Zapf; a partner at the Kelly-Winterton Press since 1978; worked at the Press of A. Colish; currently a designer/representative for The Stinehour Press; his work has won awards from the Type Directors' Club, AIGA, and the Society of Typographic Arts; work published in many books and periodicals on calligraphy and typography.

70 STAN KNIGHT Lettering artist and teacher; elected Fellow of the Society of Scribes and Illuminators, UK, in 1964; teaches calligraphy workshops in US and internationally; work included in collections of the Victoria & Albert Museum, London, the Akademie der Kunst, Berlin, the Rijksmuseum, The Hague, the Harrison Collection, San Francisco Public Library, and the Mitaka City Arts Center, Tokyo; author of *Historical Scripts*.

14, 19 RUDOLF KOCH (1876, Nuremberg, Germany–1934, Frankfurt am Main) Calligrapher, type designer, author, and illustrator; advocate of the hand-written book; wrote many beautiful manuscripts; as a type designer cut versions of his own written letters with files and gravers—his first, *Neuland*, is still very popular, especially with today's scribes; founder, teacher, and guiding force of the famous Offenbacher Werkstatt (1920–34) where skilled students and co-workers created handsome decorative works, woven tapestries, and illustrated wood-cut books; his famous published works include *The Book of Signs*, *The Little ABC Book*, and the *Book of Flowers*.

8, 57 ALICE KOETH Born in New York City; studied at Brooklyn Museum Art School with Arnold Bank; began free-lancing in 1953; calligraphy teacher since 1970; published in *Calligraphers Engagement Calendars*, *Modern Scribes and Lettering Arts*, *International Calligraphy Today* and *Lettering Arts*; on the faculty of twelve international calligraphy conferences; designed Pierpont Morgan Library posters from 1967 to 1996; a founding member of the Society of Scribes.

34 DON KUNZ Calligrapher, painter and teacher; BFA, School of the Art Institute of Chicago; studied calligraphy with Lloyd Reynolds; taught calligraphy at Queens College, NY, and at The Cooper Union since 1966.

68 CARL E. KURTZ Trained by his father, sign-painter Carl Sr., from the age of nine; although not a commercial lettering artist, has drawn, written, and constructed letterforms all his life; Professor of Art at Kansas City Art Institute, MO; teaches drawing, design, and three-dimensional studies.

63 CAROLINE PAGET LEAKE Fine artist, calligrapher, and teacher of pointed-pen scripts; began studying lettering in 1979 at The Art Students' League; taught calligraphy at The New School, New York, in workshops and privately; work has appeared in *The Speedball Textbook*, *Enrich Your Calligraphy* and the *Calligraphers Engagement Calendars*.

NANCY RUTH LEAVITT Creator of contemporary illuminated manuscript books for over ten years; calligraphy correspondent for the Guild of Bookworkers; work represented in public and private collections including the Houghton Library at Harvard University, the National Museum of Women in the Arts, Washington, DC, and the Victoria & Albert Museum, London. *94*

RICHARD LIPTON Calligrapher, sign-painter, and graphic designer since 1974; established a calligraphy/design studio in Cambridge, MA; worked for Bitstream, an independent digital type foundry; designs original typefaces and custom fonts through an affiliation with the Font Bureau, Boston; lives in Milton, MA. *12*

BYRON MacDONALD (1908–1976, San Francisco, CA) Early-on developed his expertise at quickly rendering spirited letters by painting showcards for theaters and department stores with a flat brush; calligrapher and commercial graphic artist for thirty years; scribe to the White House during the Kennedy and Carter administrations; taught the art of medieval script at the California College of Arts & Crafts; authored and grandly illustrated *Calligraphy, The Art of Lettering with a Broad Pen* (1970); a founding member of the Friends of Calligraphy. *119*

BERNARD MAISNER BFA, The Cooper Union, 1977; manuscript studies at the Bibliothèque Nationale, Paris and the Pierpont Morgan Library, New York; paintings and illuminated manuscript pages exhibited in New York and nationally since 1977; twenty-five-year survey exhibition "Entrance to the Scriptorium" currently on a three-year national tour; work included in permanent collections at the Morgan Library and the Philadelphia Museum of Art; instituted manuscript illumination program at The Cloisters, 1979; guest lecturer, Getty Museum and Morgan Library. *41*

DAVID MEKELBURG Calligrapher and designer based in Los Angeles; studied under Corita Kent; BA in Art, Immaculate Heart College, Los Angeles; MFA, California Institute of the Arts; teaches and lectures throughout the US and at many international conferences; influenced by Ray Da Boll; designer of calligraphic greeting cards since 1960, creative director of *Painted Hearts and Friends* in Pasadena, CA. *84*

JUDY MELVIN Freelancer and lettering artist for American Greetings; published in US calligraphy guild journals and *Signs of the Times*; faculty member of international calligraphy conferences; influenced by Sheila Waters and David Howells; works and teaches in collaboration with Mike Gold; currently resides in Florida. *73*

SUZANNE MOORE Freelance lettering artist, designer and teacher whose painterly books expand on the manuscript tradition; teaches book design and lettering in the US and abroad; book works represented in private and public collections in the US and Europe. *48, 52*

20 BARRY MORENTZ Studied primarily with Sheila Waters; owner of a lettering and design studio in New York specializing in calligraphy, bookbinding, and box-making; on faculty at international conferences; specializes in Gothicized Italic; considers Hermann Zapf, Gottfried Pott and Ann Hechle as major influences.

36 MAURY NEMOY (1912–1984, Los Angeles, CA) His love affair with the alphabet began in grammar school; as lettering artist and graphic designer, designed movie titles and record album covers, sometimes using calligraphic forms; became *seriously* interested in calligraphy after experiencing a lecture and bravura demonstration of writing skills by Arnold Bank at the Kahn Institute of Art—an expert at brush lettering, the transition was swift, and he immediately proceeded to master the broad-edged pen; taught lettering and typography at UCLA; provided the impetus for the founding of the Society for Calligraphy in 1974.

87 BRODY NEUENSCHWANDER BA in History of Art, Princeton University; PhD in History of Art, Courtauld Institute, London; Diploma in Calligraphy, Roehampton Institute, London; elected Fellow of the Society of Scribes and Illuminators, UK, 1985; resigned, 1992; assistant to Donald Jackson, 1987–88; freelancer since 1988; Belles Lettres Prize, 1997.

56 MARVIN NEWMAN (1924–1967, New York, NY) Graduate of the High School of Music & Art in New York; overseas army service during WWII; studied calligraphy with Arnold Bank at the Art Students League of New York and paleography with him on weekends; taught calligraphy at the Art Students League and at The Cooper Union; enthusiastic fan of Gilbert & Sullivan and the New York Yankees.

33 OSCAR OGG (1908, Richmond, VA–1971, New York) Calligrapher, designer, author; BS in architecture from University of Illinois; trained at Huxley House, New York, until 1936; three years service with the US Army Graphic Division Engineers; founded the School of Calligraphy at Columbia University in 1946; vice-president and art director of the Book of the Month Club from 1950; authored *The 26 Letters* (1948) and *Three Classics of Italian Calligraphy* (1953).

67 CHARLES PEARCE Born in England; elected Fellow of the Society of Scribes and Illuminators, UK, in 1970; came to America in 1980; currently works at American Greetings as a senior lettering designer; teaches and lectures in the US and internationally; author of several books on calligraphy.

105 ANNA PINTO Free-lance calligrapher and teacher; published in *The Speedball Textbook* and *Lettering Arts*; represented in the Harrison Collection of the San Francisco Public Library and the Dana Library, Rutgers University, Newark, NJ; lives in Hoboken, NJ.

LLOYD REYNOLDS (1902, Bemidji, MN–1978, Portland, OR) Degrees from *35*
Oregon State University and University of Oregon; joined Reed College faculty in
1929; taught English Literature and Fine Art; advocate of the teaching of italic hand-
writing to all ages; influenced the Oregon State Education Board to adopt italic hand-
writing in state schools; author of *Italic Lettering & Handwriting Exercise Book* (1957);
organized the major exhibition (and catalog) *Calligraphy: The Golden Age and Its Mod-
ern Revival* in 1958.

MARCY ROBINSON Free-lance lettering artist; studied with Sheila Waters and *113*
Julian Waters; published in *Modern Scribes and Lettering Artists, I/II, International Callig-
raphy Today, Florilège,* and the *Calligraphers Engagement Calendars;* lives in New Jersey.

GUILLERMO RODRIGUEZ-BENITEZ (1914, Vieques, PR–1989, San Juan, *25*
PR) Economic advisor to the Government of Puerto Rico; studied calligraphy with
Hermann Zapf and extensively with Donald Jackson; commissioned calligraphy
work, but also created his own in stone, glass, textiles, books, and skilled gilding on
vellum; an accomplished amateur.

CARL ROHRS Lettering artist and sign painter since 1977; teacher of lettering, *72*
typography, and graphic design at Cabrillo College, CA, since 1984; teaches work-
shops for calligraphy societies; editor of *Alphabet,* the journal of the Friends of Cal-
ligraphy, 1989–92.

GEORGE SALTER (1897, Bremen, Germany–1967, New York, NY) Started his *29, 31*
career in stage and costume design, changed in 1927 to the less hectic field of graphic
arts while in Germany; emigrated in 1934 to the US; studio in New York; designed
hundreds of book jackets in a distinctive calligraphic style; organized the Book Jacket
Designers Guild; taught calligraphy at the Columbia School of Library Service and
The Cooper Union; a calligraphic pioneer, inspired many students who went on to
illustrious careers.

INA SALTZ Graduate of The Cooper Union; studied calligraphy with Don Kunz *43*
at The Cooper Union, Hermann Zapf at RIT, and Donald Jackson; calligraphy teacher
at The Cooper Union for twenty years; art director for magazines including *Time
Magazine's International Edition, Worth, Worldbusiness, PC Tech Journal;* consulting art di-
rector at *Business Week* and *The New York Times Magazine;* currently design director of
Golf Magazine.

BEN SHAHN (1898, Kovno, Lithuania–1969, Roosevelt, NJ) Painter, designer, let- *98*
terer; emigrated to the US, 1906; studied at New York University, the Art Students
League of New York and the National Academy of Design; assisted Diego Rivera on
Rockefeller Center mural; Professor of Poetry at Harvard; illustrated *The Alphabet of
Creation* (1954) and *Love and Joy About Letters* (1963); work has been exhibited widely
throughout the US, Europe, Israel, and Japan.

82 PAUL SHAW Calligrapher and type designer; author of *Blackletter Primer, Letterform* and *Blackletter: Type and National Identity* (with Peter Bain); partner in Letter Perfect; teaches typography at Parsons School of Design.

13, 53, 95 EMILY BROWN SHIELDS Studied with Fran Manola at the Crafts Students League, New York; participated in Donald Jackson's 1974 New York City class; published in *Calligraphers Engagement Calendars* and *Lettering Arts*; designed inscriptions and logos at Steuben for eleven years; published *Lines I Like* (1986); a founding member of the Society of Scribes.

69 SUSAN SKARSGARD Lectures and teaches in the US and internationally; exhibits widely and is included in private and public collections; Senior Creative Designer for General Motors Design Center; lives in Ann Arbor, MI.

32 PAUL STANDARD (1896, Yonevetc, Russia–1992, Kingston, NY) Graduated from Columbia University School of Journalism; publicist for the Canadian Pacific Railroad; always interested in handwriting, excelled in the Palmer method before reading Alfred Fairbank's *A Handwriting Manual* in 1932; taught himself italic handwriting; enthusiastically aspired to reform American handwriting; wrote article, "Italic Handwriting" *in Woman's Day* magazine (1947) (circulation 4,000,000); authored *Calligraphy's Flowering, Decay & Restauration* (1947) and in 1979 published a complete translation of Arrighi's *Operina* and detailed pages of instruction in his book *Arrighi's Running Hand*.

61, 66 JOHN STEVENS Has an international clientele and is represented in private and public collections worldwide; one-person show ("Writing Considered as an Art") at the San Francisco Public Library and the University of Portland; included in numerous books on calligraphy and lettering and design; currently lives in Winston-Salem, NC; teaches six-month intensive study classes; faculty of The Sawtooth Center for Visual Art; exhibiting member of Associated Artists.

108 MICHAEL SULL Specializes in 19th-century American penmanship; owner of the Lettering Design Group specializing in engrossing, calligraphy, ornamental penmanship, and commercial lettering design; former lettering artist for Hallmark Cards; author of books and videos on Spencerian script; teaches workshops in the US, including the "Spencerian Saga"; on faculty at international calligraphy conferences.

49 SUSIE TAYLOR Curator of the Richard Harrison Collection of Calligraphy and Lettering in the San Francisco Public Library; calligrapher since 1970; studied with Byron MacDonald, Arne Wolf and Hermann Zapf; founding member and past president of the San Francisco Friends of Calligraphy; published in *Contemporary Calligraphy, Calligraphy Today*, and *Alphabet*, the Journal of the Friends of Calligraphy.

26, 37 LILI CASSEL WRONKER Born in Berlin, Germany; emigrated to America in 1940; self-taught with Edward Johnston's book while in high school; worked with Arnold Bank at Time, Inc.; designed book jackets since 1948 and illustrated numerous children's books; taught calligraphy at the Brooklyn Museum Art School, the United Nations International School, and Queens College; collaborated with her husband Erich on private Ron Press editions, 1955–95; a founding member of the Society of Scribes.

71 ALEXANDER H. ZANETTI BA, Rutgers University, graduate school at Pratt Institute; sign-painter, lettering artist, designer and teacher; lectures and exhibits widely; a ten-time National Sign Design award winner; recipient of awards from the Art Directors' Club of New Jersey, the Society of Environmental Graphics Designers, *Calligraphy Review* magazine, and *PRINT Casebooks*; faculty member, Parsons School of Design; included in *Who's Who in the East*.

15, 16, 58 HERMANN ZAPF Born in Nuremburg, Germany, 1918; type designer, calligrapher, and book designer; designer of more than 200 typefaces including *Palatino, Optima, Zapf Chancery,* and *Zapfino*; calligraphy reproduced widely in books and journals; author of writing manual *Feder und Stichel* (1949); reprinted with English text as *Pen and Graver* (1952); comprehensive survey of his calligraphic work included in *Hermann Zapf & His Design Philosophy* and *Hermann Zapf: Ein Arbeitsbericht*; an honorary member of the Society of Scribes.

Printed on Cougar Opaque paper at The Stinehour Press

in Lunenburg, Vermont. Title page calligraphy by Alice Koeth.

The text type is Zapf-Renaissance by Hermann Zapf.

Designed by Jerry Kelly.